JN308303

蛍の本

Photographer
田中達也

はじめに

　ホタルとの付き合いはフィルム撮影の時代からなので、すでに30年にもなる。ただ当時の私は、ホタルの生態など詳しい知識もなく、よい写真が撮れるよう様々な工夫をして撮影に取り組んでいただけであった。

　デジタル時代になり、撮影するのは以前より簡単になった。いつしか私はホタルを本格的に撮るようになっていた。すると、様々な疑問が湧いてきた。インターネットやSNSで知るホタルの情報は、どれもホタルの発生時期や飛ぶ様子を伝えるだけで、個人的な見解のものばかり。やはり自分自身で調べなければと強く自覚するようになり、自分なりのホタルとの付き合いが始まった。

　まずは子どもたちが感じるような疑問から考えた。ホタルとは一体どんな昆虫なのか、どこにいて何を食べ、どんな生き方をして、どの時期に見られる生き物なのか……だんだんと突き詰めてみたくなってきた。ところが調べれば調べるほど専門家の数も少なく、生態を観察した論文はあるが、素人でもわかりやすい書籍となると児童書が多く、これというものは数少ないことを知った。

　既存の文献で学んでいくうちに自分なりの見識も向上し、撮影に役立てることができるようになっていった。ホタルの生態や知識を得てくると撮影地や撮影時間帯も独自の読みや予測ができるようになってくる。その結果、誰もいない場所

で夜中に乱舞を撮影したり、「今年は出ない」という情報とは裏腹に大量発生に遭遇し驚いた夜も経験した。人から教わる情報も大切だが、それ以上に自分がホタルの実態をさまざまな場所で体験し、知ることができたのは、撮影者の私にとって間違いのないベースになっているのである。

こうした探究心から始まった私のホタルへのアプローチは、振り返ると20年近く前に始めたオーロラ撮影とよく似ていた。どちらも光を発する被写体で夜という共通性もある。さらに解明されていないことが多いのも同じだ。

ホタルもオーロラも撮影地と撮り方がわかれば、進化したカメラによってだれでも写すことができる。しかし自分がイメージするような光景は簡単には撮らせてもらえない。その意味からもホタルへの探求はまだまだ始まったばかりかもしれない。

本書はそうした私の知り得た学習体験に基づき、基本的なホタルの生態にふれながら観賞者や撮影者にとって日本固有の夏の風物詩「ホタル」を楽しむためのエッセンスを書き綴った。さらにホタルという幻想的な対象を被写体として撮影するためにはどのようにしたら良いのかを、基本から応用までをまとめた一冊である。

<div style="text-align: right;">自然写真家　田中達也</div>

Contents

2 はじめに

第1章 ホタルを見る　5

42 Column 1 ホタル観賞の現状とマナー

第2章 ホタルを知る　43

44 ホタルにはどんな種類があるの?　　45 ホタルはなぜ光るの?
46 ホタルの一生　　48 ホタルはどこで見られるの?　　49 ホタル観賞の服装
50 ホタルと天気の関係　　52 ホタルは何時ごろ飛ぶの?
54 ホタルはどんな飛び方をするの?　　56 ヒメボタルの不思議な光
58 摩訶不思議なホタルの光跡を楽しむ

60 Column 2 雄と雌で大きく違うミステリアスなホタル

第3章 ホタルを撮る　61

62 撮影の心構え　　64 撮影機材の準備　　66 ホタルをどう撮るか?
68 ホタルの構図選び　　70 ピント合わせの注意点
72 ホワイトバランス　　74 絞りとISO感度の選択
76 シャッター速度の選択　　78 比較明合成によるホタル表現
80 適正露出を導く手順　　82 ホタルの最適露出
83 風景としての適正露出　　84 よくある失敗と対策
88 どのくらい乱舞させるのか?　　90 星と絡ませる　　92 風景とホタルを別に撮る
94 ノイズ低減処理　　96 画像処理の基本テクニック①明るさ
98 ②彩度　　100 ③色かぶりを補正する

102 Column 3 撮影時の喜怒哀楽がホタル撮影の醍醐味

第4章 ホタルに逢う　103

第1章

ホタルを見る

01＿チカチカ、チカチカ。小さな閃光を発しながら竹林の中を移動するヒメボタル。静寂の闇に数匹が飛び始めるとショーの開演だ。みるみる増えていく光の点滅は右へ左へとランダムに彷徨う。ピークを迎える頃、一帯は神秘の光に埋め尽くされる。

02＿トワイライトタイムは日没から夜が始まる間のわずかな時間帯。辺りの景色は刻一刻と闇へと近づく。森の奥から小さなヒメボタルの光がやってきた。あとを追うように次々と仲間が飛んでくる。まっすぐ森の出口に飛び去るホタルもいれば、同じ場所を行き来するホタルもいる。いつしか夜の森にホタル道ができあがった。

03＿人々が寝静まった真夜中、それは予想もしない出来事だった。直前まで普通に瞬いていたヒメボタルの光が、突如四方八方へと飛び交い始め、セットしたカメラを包み込んでいく。カメラがとらえた無数の光を重ねていくと、そこには大宇宙の銀河を彷彿とさせる絶景があった。

04＿狭い一本道が木々に囲まれトンネルのように数百メートル続く。南側から高速道路のナトリュウム灯と繁華街からの街明りが木漏れ日となって小道を照らす。都市部で見られる珍しいヒメボタルの繁殖地だが、ピーク時には訪れた人とホタルが行き交う銀座通りとなる。

05＿小川に薄暮の空が反射し、周辺にはブルートーンの空気が忍び寄る。上流の木々から点滅を始めたゲンジボタルが飛び始めた。しばらく岸辺に群れていた光は堰を切ったように下流へと移動を始めた。きっとそっちにお気に入りの雌たちが待っているのだろう。

06＿自然が残る山間で家族連れが蛍狩りを楽しんでいる。訪れた人たちはせせらぎが奏でる涼しげな音色をBGMにゲンジボタルの舞いを眺めている。暗い田んぼ道を散策する人、しばし立ち止まり夢心地に浸るカップル。ここには昔ながらの初夏の風情があった。

07＿一晩に数千匹のゲンジボタルが乱舞する長野県辰野町の「ホタルの里」。訪れる人の数も多いが、徹底したマナーの呼びかけと無灯でも安心なバリアフリーの遊歩道になっていてライトを付けて歩く人はほとんどいない。満天の星空にホタル舞う光景があちこちで見られ、観賞にも撮影にも適したホタルの楽園だ。

08_集落から少し離れた小川でゲンジボタルの群れが活動を始めた。
のどかな田園風景の広がるその奥には民家の明かりも灯りだした。
人とホタルが共存共栄する、まさに初夏の風物詩。里山にホタルが
飛ぶ風景はいつまでも残しておきたい日本の誇れる風光である。

09＿曲がりくねった山間の道を進むと木立の間から勢いよく音を立てる渓流が見えてきた。空には雲間から星が見え始め、数百メートル先の街灯が川岸を照らしている。そんな渓谷をスゥーとツバメのように飛んで行くゲンジボタルの姿が目に飛び込んできた。

10＿天然のゲンジボタルはどこかのんびりと優雅に舞う姿が印象的だ。そんな落ち着いた環境に遠くからこちらに向かって車のライトが差し込んできた。するとホタルは驚いたように急上昇した。我々にとっては何気ない光でもホタルにとっては警戒する光なのだろう。

11___耳を澄ませば、近くを流れる川からの水音と重なるように聞こえるカエルの合唱。林を抜ける心地よい風が木々を揺らしてカサカサと囁く。梅雨の季節に欠かせない心地よいヒーリングミュージックである。そんな音楽にリズムを合わせるかのように一匹のゲンジボタルが通り過ぎていった。

12＿小さな村の守り神をまつった祠の横にある不動滝。小ぶりの滝だが開けた滝壺と左右対称に落下するツインフォールである。水飲み場に集まる野生動物のようにヘイケボタルが乱舞を始めた。その横をゲンジボタルが何気ない顔で通り過ぎ、明るく長い光跡を放ちながら滝に寄ってきた。今宵はここで舞踏会があるらしい……。

13__海沿いの集落を流れる川岸に、地元で「ホタルの木」と呼ばれる木がある。見過ごしてしまう普通の樹木なのだが、ホタルの季節だけは特別だ。どうやらこの木に集まるホタルがイルミネーションを演出するらしい。確かにこの木の下の川面には群がるように飛び交うホタルの姿があった。だがいつでも見られるわけではないという。

14＿ホタルの名所は、知名度の高いところもあれば地元だけのささやかな名所もある。住宅街の脇にある鎮守の森では小川から水を引き込み、地元の子供たちがビオトープを作り世話をしている。そこを訪れたのはすでに人が寝静まる頃。誰もいない森の中で星空を見上げたとき数匹のホタルが頭上をよぎった。

15＿夕涼みはホタルを見るのにちょうどいいひと時だ。夕焼けが終わり、星が瞬き始める頃、時を同じくしてホタルも飛び始める。薄暮の中で眺める光景は輪郭だけが強調され、どことなくシンプルだ。そんな景色を眺めつつ散歩する脇をホタルの光が心地よく迎えてくれる。

16▬ホタルの季節といえば6月中旬から7月初旬が一般的。梅雨が終わりかけ、「初夏」という端境期だ。晴れる日も多くなり、夜空には昇り始めた星たちが輝きを増す。夏の星座とホタルの競演はまさにこのタイミングである。この日も午後8時には稜線からサソリ座が昇ってきた。

17＿澄み渡る夜空は満天の星が迎えてくれる。そんな星たちの輝きをバックに従えホタルはやってくる。遠く山裾から田んぼを渡り、近くまでやってくるには訳があった。この景色の背後には小川が流れ、その奥には竹林がある。甘い水があるからではなく、ここに留まる雌たちの誘いに惹かれてやってきたのだ。

18__休憩中のゲンジボタルを観察していると発光にも違いがあることがわかる。明るく放つ光は、周囲の葉っぱを透かし、その反射光が自らをも浮かび上がらせるほど明るい。なかなか見ることのできない姿だが、眺めているとお尻を上げて愛嬌のある仕草を見せてくれた。

19＿闇に浮かぶヤマボウシの白い花。ミズキ科のこの花木は、常に水を好むためゲンジやヘイケボタルの飛んでいるエリアではよく見かける。水路添いに咲く花の存在が、ホタルの光跡ともマッチして画作りに活かされたことは言うまでもない。

20＿群青色の空気が辺りを包み、ほのかに浮かび上がる幽玄な風景。木々の生い茂る渓谷での撮影。頼りは星明かりと道路添いの街灯から届いたわずかな光。上流からやってくるゲンジボタルの光跡を眺めていると、放たれた蝶の群れがやってくるようにも見える。

21_杉林に隠れるように流れる小川はゲンジボタルのたまり場。しかしそこには樹高20メートルを越す杉が野放図に林立している。ここのホタルの見所は上を目指して群れて飛翔する行動パターン。上昇下降を繰り返す光を眺めているだけで爽快感を味わえる。

22＿ホタルの魅力は発光であるが、見た人の思いや驚きが詰まっている。幻想的な光といってしまえばそれまでだが、さまざまな味わいがあると思う。葉に止まって休んでいるホタルにはほのかな灯火を感じ、飛翔するホタルには流れ星のような動きを感じる。

23＿なにげに星空を眺めていると星屑の中を悠然と泳ぐように空高く飛ぶホタルがいる。群れて飛ぶ時とは対照的で直線的な単独飛行が多い。きっと遠くへ移動する時の飛び方なのだろう。それを眺めた時、あたかも天に昇っていくかのような夜間飛行に思えた。

Column 1

ホタル観賞の現状とマナー

　ホタルの観賞者数は、観賞地の充実や地域おこしの一環でホタル祭りを行う自治体もあり、年々増加傾向にある。全国的にも有名な長野県辰野町は、観光バスで訪れるツアー客や家族連れで賑わう。こうした場所は散策路も整備され、安全管理も十分だ。さらにホタルガイドがいたり、案内所が併設されていたり、マナーに関するアナウンスもあって誰でも安心してホタル観賞を楽しめる。
　それと対照的なのは山里にあるホタルの名所。観賞者を誘致するためにアピールしたい自治体と反対する住民との間で確執が起こっている地域もある。そんな地域を訪れると駐車場もなく道路脇で眺める場所が多い。そのため観賞時間が近づくと続々と車がやってきて路上駐車の列が出来上がる。狭い道路での往来が短時間に集中し、車のすれ違いによるトラブルや観賞者が捨てる煙草の吸い殻、空き缶、食べ物のポイ捨てが放置され集落の迷惑になっているところもある。
　失われつつある日本古来の風情を身近に楽しむことのできるホタル観賞は、今やマナーの上に成り立っている。自分勝手な行動が観賞地の衰退や、ホタルの発生そのものの減少へと追い込む結果にならないようホタルが棲む本来の環境維持を一人一人の観賞者の心がけとして自覚したいものである。

第2章

ホタルを知る

ホタルにはどんな種類があるの?

水生ホタルと陸生ホタル

　ホタルはカブトムシやテントウムシといったコウチュウ目（鞘翅目）のホタル科に属した昆虫で、世界に約2000種類いるといわれている。幼虫時期には羽根がなく、羽根の元となる翅芽（シガ）が育ち、サナギになると羽根が体の外に作られ、羽化して成虫となる「完全変態」の昆虫である。その多くが雨の多い熱帯地域に分布する。

　ホタルの見られる場所といえば、日本では一般的に「川や田んぼ」と思われがちだが、それは一部のホタルであり、木々の生い茂った森林地帯や水辺のない林の中で一生を過ごす種類も多い。そのためホタルは、幼虫時期を水中で過ごす「水生ホタル」（ゲンジボタル・ヘイケボタルなど）と陸上で過ごす「陸生ホタル」（ヒメボタルなど）に分けられる。

ゲンジ・ヘイケ・ヒメボタルが代表的

　日本では、北海道から沖縄まで幅広くホタルが分布し、約50種と言われている。その多くは九州以南の南西諸島に生息している。日本のホタルの代表的なものは、ゲンジボタル・ヘイケボタル・ヒメボタルの3種類。夏の風物詩として例えられるホタルといえば、ゲンジボタルが有名だが、地域によっては、ヘイケボタルやヒメボタルが地元のホタルとして親しまれているところもある。ちなみにゲンジボタルは日本固有の種類である。

　そのほかにも種類が多いものにマドボタル属がある。本州・四国・九州に見られるクロマドボタル、オオマドボタル、対馬には大型のアキマドボタル、南西諸島には島や地域の名のついたオキナワマドボタル、ミヤコマドボタル、サキシマドボタル、オオシママドボタルというように種分化がすすんでいる。また日本全土で見られるオバボタルがいる。1センチ前後と小さく、夜間の活動はしない昼行性である。

ホタルはなぜ光るの?

メスを探して光りながら飛ぶ

　ホタルは深海魚のアンコウやホタルイカのように自らの体内から光を生み出して放つため「発光生物」といわれる。しかし、発光生物の多くが魚類であることに対し、淡水や陸上で生息する昆虫の発光は、種類も限られている。そうした現状からも我々にとって身近なホタルの発光は貴重なものである。

　発光生物が光を発する意味は、獲物をおびき寄せたり、外敵から身を守るための行動として知られるが、ホタルの場合は、子孫を残す求愛行動とされる説が有力である。また、自分の居場所を相手に知らせる意味を持つ。しかし、それはホタルが成虫になってからの繁殖行動のひとつである。

　ホタルは成虫になってからではなく、幼虫時期や種類によっては卵の段階から発光する。そうした種類もあることから敵を脅かしたり、反対に敵から身を守る警戒色として進化したとも言われる。

化合物質の化学反応によって光る

　ホタルが光を放つのは腹部の体節に発光器を持っているからである。その中でルシフェラーゼという発光酵素とアデノシン三リン酸（ATP）という化合物質が化学反応を起こすことでルシフェリンと呼ばれる発光物質となり、光が放たれる。ホタルの光は電気と違い、熱をほとんど発生させないことから冷めた光「冷光」と呼ばれる。

　そんな生物学的に希有なホタルの発光だが、光の強さや色の違い、さらに発光のサイクルといった光の放ち方が種類によって異なる。

ホタルの一生

7日〜10日の命

　一般的にホタルを見るのは初夏である。同じ場所で観察しているとホタルが飛び始めてから見られなくなるまでの期間はおよそ10日から20日。地域や天候、気温の差によって幅がある。一匹のホタルがこの期間に生存できるのは、おおむね7日から10日といわれ、オスよりもメスのほうが数日長い。またホタルにも個体差があり、早く羽化して飛び始めるものもいれば、遅れて羽化するホタルもいるため観賞期間に幅が生まれる。

　ホタルの一生は1年だが、暖かい地域で育つヘイケボタルは半年で成虫となる二化性のホタルもいる。ホタルは、この成虫期間に子孫を残すための交尾を行う。オスはメスを探し求め、メスは卵を産み終焉を迎える。産みつけられた卵は一年をかけて成虫となり、我々の目を楽しませてくれるのだが、その一年の歩みは平坦なものではない。

幼虫期が生育期

　そのプロセスを、ゲンジボタルを例に説明する。交尾を終えたメスのホタルは夜な夜な卵を産みつける安全な場所の選定に余念がない。水辺の近くでコケなどの柔らかな草を探し産みつけられた卵は平均500〜750個で、多い個体では1000個を越える。卵が順調に育てば約1ヶ月で幼虫となる。孵化した幼虫は地上から水中へと移動し、流れの緩やかな小川などの水場でカワニナを主食に約8ヶ月間を過ごし、その間に5〜6回脱皮する。そして、4月から5月の雨天や雨上がりの夜に一斉に陸に上がり、土中に繭を作り、30日ほどでサナギになると、さらに15日ほどサナギで過ごしてようやく羽化し、付近を飛び交うのである。

　この期間の中でもっとも長い幼虫期こそが生育期であり、捕食が重要となる。その食欲は旺盛で一匹の幼虫が水中で過ごす間に捕食するカワニナの量は、成長するホタルの幼虫のサイズに合わせて稚貝を含め約100匹といわれる。ホタルは成虫になると一切捕食をしないため食欲が旺盛なのだ。成虫には捕食するための大きな口がなく、水を飲む程度の小さな口があるだけ。よって幼虫時期に蓄えたエネルギーで飛び回っていることになる。

外敵や自然災害を乗り越えて

　ゲンジボタルの幼虫が生育するこの期間には、さまざまな危険が待ち構えている。幼虫を餌としてねらう他の生き物からの危険をはじめ、自然災害、そして人

ゲンジボタルの一生

- 羽化（6月中旬〜下旬）
- 交尾
- 産卵（6月下旬〜7月上旬）
- コケ
- 孵化
- ホタルの幼虫
- カワニナを食べて成長する
- 幼虫の上陸（4月下旬）
- さなぎ（5月）

的被害といったものが挙げられる。特に集中豪雨は、ホタルの発生率を大きく左右する。大水は豪雨に限らず、春先の長雨でも発生する。陸に上がる前の3月から4月の大雨は要注意となる。大雨は、単に水かさが増えるだけでなく、勢いのある水が長時間流れることで川底が一掃される。そうなるとカワニナもホタルも流されたり、土砂に埋もれてしまいホタルの生活環境が奪われる。災害が起こるとその年以降のホタルの発生数が急激に減少したり、発生場所が下流へと移行するのはこのためである。

人間社会との共存がキーワード

また、人的被害として田畑における農薬の散布がある。これにより川の生態系を変えてしまう事例は後を絶たない。ヒメボタルのような陸生ホタルの場合は我々が生活する近くにも生息している。小川といった水の流れがなくても十分生息できるため雑木林や竹やぶに見ることも多い。そうした環境は人間社会との共存共栄が大きなキーワードとなる。

ところが道路の拡張や宅地開発が進めば生息域は狭まり、生育環境も変わる。エリアが保護されても日照状況や風の流れなどそれまでの環境とは違ってくれば地中の水の流れが変化し、その場所の土壌が変化して土が乾燥しやすくなったり、逆に湿度が高くなって土中にカビが発生しやすくなる。すると捕食する餌が減少したり、繭を作ってもカビに侵され、羽化にまでたどり着けなくなってしまうのだ。

環境が変化するということは、一言では言い尽くせない様々な苦難の連鎖が始まり、安定した生息域とはいえなくなる。結果的にホタルの減少傾向につながる。昔のようにホタルが風物詩として自然に見られる環境に戻すためには多くの人の理解と時間が必要なのだ。

ホタルはどこで見られるの?

情報収集をして出かける

　ホタルを見たいのであれば、まずは身近な場所でホタルの見られる観賞地を探してみてはいかがだろう。市街地の近くでも意外な場所でホタルを見つけることができる。

　自然発生するホタルの里は今も昔も変わらず静かな山間のエリアが多い。そこへ向かうルートは必ずしも整った道ばかりではない。細い村道や林道を抜けていくこともある。もちろん集落は静かな夜を迎えようとしている。里の近くであれば地元の人に迷惑をかけない心配りは大切なマナーである。

　近年、ホタルの生息環境が減少傾向にあることは否めないが、保護も盛んになりたくさんのホタルが見られるところも増えている。休耕田を活用して人工的にホタルのすみやすい環境を整え、維持していたり、小学生の授業の一環としてホタルの幼虫を育て、川に放流し、観賞を楽しむ地域もある。さらに天然のホタルが一年を無事に過ごせる環境を整えている地域も少なくない。こうした保護活動によって天然のホタルの保全や放流したホタルから自然繁殖しているところも増えつつある。

ホタル観賞の服装

軽装での観賞は要注意

　整備された観賞地では半袖にトレーナーを腰に巻き、サンダルやスニーカーといった普段着姿の人が多い。ホタル祭りなどのイベントでは浴衣姿の子どもや若い女性など風情にマッチした出で立ちで楽しむ姿もたくさん見かける。私自身、幼い頃はうちわを片手に浴衣姿で縁側に座り、庭先に飛んでくるホタルを眺めたものである。

　しかし、本来ホタルの生息地は水辺や草むら、畦道や林など草木の茂みが多い。そこにはマムシやヤマカガシなどの毒蛇、ムカデやハチ、さらにブヨや蚊など人間にとって害をもたらす危険な生き物も共存している。ホタルという幻想的なイメージを抱かせる昆虫だから危険を感じさせないことで普段着のまま軽装で訪れてしまうのだろう。

虫除けスプレーはNG

　もっとも注意したいのは足元である。サンダルやスニーカーに半ズボンやスカートは無防備そのものである。もし道路脇の草むらにマムシが潜んでいたら一歩足を踏み入れれば一撃でかまれてしまう。「あっ、そこそこ」と草に休んでいるホタルに手を伸ばすことも要注意。草むらには蜂の巣がある場合も多い。

　とくに長時間その場所に滞在する撮影者は、ブヨや蚊の襲来も多いので完全防備を心がけたい。だからといって虫除けスプレーはホタルにとって害になるので使用は避けること。やはり虫除けスプレーをしている人の近くにはホタルはやってこない。

　完全防備の出で立ちとなると、長靴を履き、長袖・長ズボンは最低限のスタイル。顔や首を守るにはタオルを首に巻き、帽子をかぶる。これは農家の方が作業する服装と同じである。夜でも蒸し暑いこともあるので、長袖でも薄着を心がけ汗をかかないようにしたい。

ホタルと天気の関係

悪天候が続くと死活問題

　ホタルがたくさん飛ぶのは、新月の晴れた風のない穏やかな日だとされる。確かに明るい月夜は、ホタルの光も届きにくくホタル同士の交信にも効率が悪い。雨の日は飛んでも羽根に雨がかかるため無理して飛ぼうという気分にはならないだろう。さらに風の強い日は飛びにくい。ホタルのシーズンとなる6月から7月には梅雨や台風の発生もあり、そんな日は最悪の夜となる。天気を読み取ってでかけることが確率の高い観賞に繋がる。

　しかし、ホタルにとっての天気は、観賞する我々の都合とは大きく異なり、悪天候が続けば死活問題を招く大きな意味を持つ。ホタルはわずか10日ほどの寿命しかない。天気次第でデートも子孫を残す確率も低くなってしまうからだ。

天候を察知し
フルに活動する

　自然界にとっては天気の隙間というものが存在する。たとえ雨が降っていても急に晴れ間が覗いたり、風が止んだり、

さらにこうこうと照らす満月の光でさえ、雲が遮れば月のない夜とそれほど変わらない。また、一晩中、月が見える夜は、満月前後の数日。ホタルはこうした大自然の巡る天候を本能で察知し、短い生涯をフルに生き抜いているのだ。

一般的にいわれるホタルの見頃は、人間の都合である。本気でホタルを観察したいのであれば、月の出入りの時刻を調べたり、ホタルと同じように天気の隙間もねらったり、あえて悪天候に出かけ実態を確かめることでよりホタルの生態に興味がでてくるのではと思う。

雨の日、ホタルは木の下を悠々と飛んでいた。

定説を越えた出来事も

小型のヒメボタルは天候に左右されることは、ゲンジやヘイケボタルに比べて少ない印象を受ける。それは林の中に生息し、低空を飛翔する性質が幸いしているのだろう。林の中は雨が当たりにくく、幹のたもとは風も避けられる。林は天候に左右されない最適な環境なのだ。

ある大雨の夜、ヒメボタルの状況が気になって傘に雨カッパと長靴という出で立ちで撮影にでかけた。幾分小降りになったが、散策路には水たまりができ、ぬかるんでいる箇所もある。だが、驚くことにそんな天候にも関わらずあちらこちらで光を放つホタルの存在を確認した。そしてまもなく、いつものように乱舞が始まったのだ。そのとき時刻は日付けの変わった真夜中の時間帯であった。

もしかして、というわずかな期待と勝手な仮説から出かけたが定説や常識とはかけ離れた予想外の出来事と遭遇した。まだまだホタルには我々の知らない未知な行動が潜んでおり、思いがけない出会いもあると改めて感じた夜だった。

雨の日は飛ばない?

「ホタルは雨の日には飛ばない」と言われるが、観察していると雨の中を悠々と飛ぶ個体も少なくない。数は決して多くないが、そうして飛ぶホタルがいると、雨量が少なくなった時につられて飛び始めるホタルが増えてくる。それは、雨が避けられる林の近くや待機している仲間がいそうな場所が多い。川岸の茂みからその近くの林の木々を行ったり来たりする個体もいる。雨のかかりにくい大木の下の空域を飛ぶ賢いホタルもいる。

ただし、雨天でも風のある日には飛んでいる姿はほぼ確認できない。たとえ飛び立っても風に煽られて上手く飛べないことを本能的に知っているからだろう。同様に草木に待機しているホタルの点滅も減少する。風で揺れる状態では落ち着いた発光もできないからだ。

ホタルは何時ごろ飛ぶの？

一幕だけで終わらない日もある

　ホタルは種類や生息環境によって見られる時間帯が異なる。よく「20時から21時頃」といわれるが必ずしもそうとはいえない。確かにゲンジボタルは、この時間帯に見かけることの多い種類である。日没後、あたりが暗くなり始めると川沿いの土手に一匹、また一匹とホタルの光が灯り始める。するとまもなく一匹のホタルが土手を離れるように空へ向かって飛び出す。これがスタートの合図。気づくと辺りはだいぶ暗くなっていて、何匹ものホタルが舞っている。

　同じ場所を行き来するものもいれば、遠く離れた場所へと飛んでいくものもいる。幕開けから30分ほど経過した頃になるとホタルの乱舞する光に酔いしれるのである。その後、時間の経過とともに飛ぶ姿が少なくなり、草むらで点滅する光へと変わっていく。これがゲンジボタルの華やかなショーの第一幕である。

　多くの人がこれで終わりだと思い、帰路へと向かう。ところが終了から１時間ほど経過した22時頃には第二幕が始まる。こうして一晩の間に何幕も見られることもあるし、一幕で終わってしまうこともある。ただ、乱舞こそなくてもホタルはまばらではあるが朝まで見られる。また、雨上がりが夜遅くなると、夜半から幕開けが始まり乱舞することも少なくない。

20度以上がひとつの目安

　ホタルが飛ぶのには気温も関係がある。私の経験からすれば気温が20度以上あり

雨風がなければかなりの確率でホタルを見ることができる。20度以上でも気温が下がり、辺りが冷え込み始めると活動はおとなしくなり、雨上がりのように上昇傾向になると活発になる。「今夜はなかなか乱舞が始まらない」とか、「今日は飛んでいる数が少ないな」と自己判断して諦めて帰宅してしまうのはいささか早合点である。ホタルにとって最適な夜には、一度乱舞が終わったとしても、それは本当の終了ではない。私は「ホタルの休憩」と呼んでいるが、時間的な間隔をおけばまた飛び始める。そのため一晩に何度も乱舞を見る夜もあるのだ。

ホタルはどんな飛び方をするの？

種類によって飛び方が異なる

　ホタルは光を灯しながら飛翔する姿が見どころで、薄暗い景色や星空と重なると風情を醸し出す。広い範囲を優雅に飛ぶのはゲンジボタルやヘイケボタルである。ゲンジボタルは放つ光も明るいが、飛ぶ速度も速い。そして点灯している時間も他のホタルに比べて長く、地域差がある。点灯時間の差はホタル研究の第一人者である大場信義氏によって発見され、わずか数秒という点灯時間に「東日本タイプの4秒」と「西日本タイプの2秒」という違いがあるという。さらに日本の東西で明確に二分されるのではなく、境の地域では東西の中間的な3秒点滅のホタルも存在するといわれる。

　ホタルの飛び方は点灯時間だけでなく飛行する経路にも種類の違いがある。ゲンジボタルは緩やかなカーブを描き蛇行しながら飛んで行くが、ヘイケボタルは直線的で急上昇も得意。目線近くの高さを飛んでいたかと思えば一気に10メートル以上の高さに飛んでいくシーンもしばしば見かける。樹高の高い杉林の際から群れて急上昇する様は見応えがある。

　ホタルで飛ぶのはオスが多く、メスは葉陰でもぞもぞと動き回る程度で行動範囲は狭いことが多い。もちろんオスと同様に光を放つが、点灯のサイクルは微妙に異なる。メスの光はオスを引き寄せるためのサインであり、フェロモンと同じような効果を持つとされる。オスはメスを見つけると獲物を見つけた鷹のように一気に近づいてく。また飛行中にホタル同士が絡み合い落ちていくシーンもある。写真では直線的な光跡から突然糸が絡むような光跡となり途切れてしまう。

強い光はホタルの大敵

　ホタルが突然飛ぶのをやめたり、落下するように変化する場面は、生態的な行動のほかに強い光が当たった時にも起こりやすい。特に通行中の車のライトがホタルを照らしたときや、観賞に来た人がホタルに向けてライトを照らす迷惑行為といった時だ。夜行性のホタルにとって強い光は目がくらむといった感じで、その後の飛行に大きな影響を与えかねない。

ホタルの観賞地では「ライト厳禁」といった看板が立ててあるのはそうしたホタル保護のためである。人には夜道を照らし、闇からの不安を解消するためのライトだが観賞時には消灯を心がけたい。

　ちなみに人間の目は車から降りた直後は、足下も見えないほど真っ暗闇に感じる。それは瞳孔が開いていないからで、目を暗い景観に馴染ませるにはおよそ20分ほどかかる。時間が経過することで夜の暗さにも目が馴染んで、辺りが見えるようになり、ライトの必要性を感じなくなる。

ヘイケボタルの撮影中にゲンジボタルが画面を横切った。左に抜けていく光跡を見れば、小刻みなヘイケボタルの光跡に対してゲンジボタルは明るく力強い。さらに色や太さ、そして長さが大きく異なることがわかる。

観賞時に強い光を放つのはNGだ。

ヒメボタルの不思議な光

フラッシュのように点滅する

　近年、写真愛好家が注目するヒメボタルは、ゲンジボタルやヘイケボタルとはひと味もふた味も違った飛び方をする。最も特徴的なのは光の放ち方。別名フラッシュボタルともいわれるように、点滅のサイクルが他のホタルと大きく異なる。ヒメボタルばかりが注目を浴びるが、沖縄に生息するヤエヤマボタルも同様にフラッシュのように点滅する。

　ゲンジボタルがツバメのようにスゥーと飛びながら数秒間ピカァーと光を放ち、数秒間消灯し、再び点灯というスローリズムの点滅サイクルを繰り返すのに対し、ヒメボタルは0.8秒に1回ほどの速い連続した点滅を繰り返す。ゲンジボタルと比べると半分ほどの小さなホタルなので飛翔速度も極端に遅く、行き先を指先で追えるほどある。そのため写真で写すと見事な点線に写る。右の写真のように時間を重ねていくと幻想的でさえある。

現場の暗さに目を慣らす

　もちろん体の小さな存在は、放つ光の明るさもゲンジボタルの比ではない。数10メートルも離れると光の存在がわからなくなるほどだ。だが人の目には見えない光も写真にすると、街のイルミネーションのように見える。飛翔する高さも低く、足下やひざ下を飛ぶ姿は愛おしくなる。そんな可愛らしいヒメボタルは、初対面では現場の暗さに目を慣らすことから始めたい。ヒメボタルの弱い光の点滅を肉眼でキャッチできるには20分ほどかかると思ったほうがいいだろう。

　観賞地を訪れる若い女性の声を聞いていると、「ねぇ真っ暗！」「どこにいるのよ……」といった感じだが、しばらくすると「あっ、いたいた」「えっ、どこどこ」「わぁっ、すごい、カワイイ！」という歓喜の声に変わる。

発生時間に差がある

　ヒメボタルの発生地をいくつか巡ると発生時間も地域によって様々だ。あるところではゲンジボタルと同じように薄暮の終わった20時頃から21時頃にピークを迎える場合もあれば、夜も深まる23時頃から光り始める地域もある。さらに深夜2時頃に絶頂期を迎えるところもある。

　またヒメボタルは4月に見られる地域もあれば、7月に入ってようやく見られるといった地域差もある。この差は、気温である。都心部に近いほど気温も高いため発生する時期が早く、標高の高い地域や山間部といったところであれば夏が始まる頃となるのだ。

摩訶不思議な
ホタルの光跡を楽しむ

観察すると面白い

　ホタルの光は種類によって点滅のパターンが異なる。しかし、同じ種類でも個体差があり、すべて同じというわけではない。このことは目視で観察していてわかる時もあるが、一般的にはわかりづらい。ところがそんな光のパターンも光跡として再現される写真では意外にわかりやすくなる。

　実は、よく観察していると、不思議な動きを見せることもある。その真意はホタルに尋ねてみないとわからないが、ある程度の推測は可能である。羽化したばかりでうまく発光できないいわゆる初心者タイプ。何らかの障害を持つ個体。寿命がつきる前の老いた個体。非凡な発光能力を持つ個体……など、さまざまな個体が存在している。

　こうした個体がどんな光跡を見せるのかは右ページの写真を見ればわかる。ただ普通に飛ぶホタルとはあまりにも違った動きなので、誰もが思い浮かべるホタルが飛ぶイメージからは、かけ離れてしまう。なかには、シャッターが開いている間にカメラが大きく動いた時の写り方に似ているためか、失敗したカットのように思えてしまい敬遠されやすい。

　私も最初はそういう思いがして、作品選びの段階で除外してきたが、あるときあまりに不自然な光跡のカットを撮影したことからどうしてこんな飛び方をするのだろう、という疑問が生まれた。それがきっかけとなり、今まで撮影したカットを見直してみると、意外にも変わった発光パターンが多いことに気がついた。探せば探すほど不思議な光跡は見つかり、いつしかコレクションができるほどとなった。

写真的な面白さがある

　通常のホタルの光跡は、種類ごとに飛び方や発光パターンが異なるため、群れると美しさを感じることが多い。しかし摩訶不思議なホタルの光は、いくつかの光跡に分類できるが、見た目の光跡に同じパターンは少ない。例えば幾何学模様的な光跡、仮名文字を連想させる光跡、点滅をせずに発光したままの光跡など興味深い光跡が見つかった。

　また風の強い日に一斉に飛び立ったホタルが風にあおられるシーンや飛び立ったもののすぐに引き返す場面。枝先をトライアングルのように縁取る光、飛翔中にホタル同士が絡み合い、糸がもつれる

ような光跡として写るケースなど意外性も加わり、不思議な魅力を感じさせる。普段見られるリズミカルで美しい光跡とは対照的なところが、写真的にはユニークな光跡と感じてしまうのである。皆さんの目にはどのように映るのだろう。

Column 2

雄と雌で大きく違うミステリアスなホタル

　ホタルの疑問のひとつに雄と雌の違いがある。一般にほ乳類では雄のほうが大きく雌が小さい。ところが昆虫の世界では雌のほうが大きく雄が小さいこともある。それは雌の体が大きいほど産卵する卵の数も多くなるため子孫繁栄には有利に働くといわれる。同じホタル属の中にも大きな違いがある。多くのホタルは雄が小さく、雌が大きい。しかし、ヒメボタルは雄が大きく、雌が小さい。生息地域の自然環境の違いによって進化の辿る道が違ったのだろう。

　1986年に大場信義氏によって発見され、1994年に新種と認定されたイリオモテボタルの雌は、幼虫時代の芋虫形のまま成虫なる幼形成熟のため一般的な雄の形態とは異なる。さらにこの雄には発光器がないといわれる。つまり「ホタルの光」が雄には見られない。だが芋虫形の雌は腹部に発光器があり、一生懸命お尻を持ち上げて発光を続け、雄を呼び寄せる。発光器がないということは光の交信ができないと思われがちだが、イリオモテボタルにとっては無用なこと。ホタルにしかわからない特別な交信方法があるのだろう。

　雄と雌の違いを探求していくと、ホタルといっても種類の異なる別の昆虫なのではと思いたくなるほどの違いがある。「なぜだろう……」また新たな疑問を抱いてしまうのだ。

第3章

ホタルを撮る

撮影の心構え

他の人に迷惑をかけないのが基本

　ホタルは星の撮影と同様に薄暮から夜の撮影である。時間の経過とともに手元も足場も確認しづらくなる。初めてホタルを撮影する場合は、撮影キャリアの有無に限らず、細心の注意を払い、周辺が確認できる明るい時間帯から撮影準備に取りかかることが必要である。

　ホタル観賞の人気スポットでは、ホタルが飛翔する時間になっても設定が上手くいかず、盛んにライトで手元を照らしている人をよく見かける。しかし、本人は手元を照らしているつもりでも、ホタルの舞っている前方を照らしていることが多く、露光中の他の撮影者の画面にはその光が映り込んでしまい迷惑である。

　撮影者はこうしたトラブルを避けるためにも撮影中にライトは極力使用しないようにしたい。どうしても必要な場合には、迷惑のかからない場所へ移動して対処する気配りが必要だ。それにはライトは手元だけを照らせるように黒テープで遮光や減光する工夫をしたい。

　さらに高輝度LEDなど白色光は夜に慣れた自分の目にも悪影響となるので、目に優しい赤色光がおすすめ。加えて両手の使えるヘッドライトが適している。

自宅で練習する

　夜の撮影に慣れるためには数多く現場を経験することがレベルアップにも繋がるが、初めての撮影には自宅での練習が効果的だ。その方法は室内の電気を消してカメラを操作するという簡単なもの。ボタン操作の多い最近のカメラでは目をつぶって操作することなど不可能に近い。だが暗闇でもどこのボタンを操れば切り替えができるかということは習得しておきたい。

ワンポイントアドバイス

コンパクトカメラでもホタルが撮れる！

　ホタルの撮影は難しいと思われがちだが、本格的な一眼カメラでなく、一部のコンパクトカメラでも設定次第や、星空を撮るモードで驚くほどよく写ることもある（写真下は、キヤノンPower Shot S120で撮影）。

暗闇での撮影は、カメラの操作はもちろん、足元も暗いので注意して歩かなければならない。小川の付近などは誤って落ちないように。

撮影機材の準備

カメラ選び

　ホタルの光は、輝度が低いので昼間と同じ設定では写らない。ホタル撮影は数秒から数10秒という長秒シャッターが必要である。そのためカメラの設定で長秒シャッターが選択できることが大前提となる。多くの一眼カメラはオートで30秒まで対応できる。また、マニュアル設定では30秒までを段階的に選択可能である。さらにバルブ（Bulb）シャッターを選択すれば1分でも1時間でも任意のシャッター速度を得ることができる。

　コンパクトカメラの場合、ホタルが撮れるのは高級機に限られる。夜景モードなど高感度設定に切り替わるシーンモードでの対応となる。最近の機種では星空モードが選べる機種があり、長秒対応するためホタル撮影に応用できる。

レンズ選び

　ホタルの撮影に適したレンズは広角から標準レンズで問題ない。焦点距離でいえば24ミリから70ミリ付近となり、標準ズームでカバーできる領域である。離れた場所を狙うのであれば、70～200ミリといった望遠ズームを持っていけば、撮影範囲が広がり、表現も多様化する。

　また、できることなら開放F値の明るいレンズを選びたい。「明るいレンズ」があれば、露出時間の短縮やISO感度の選択肢も広がる。特に単焦点レンズにはF値の明るいレンズが豊富で、ズームレンズに比べて小型軽量と携帯性にもメリットは大きい。しかし、ズームレンズのように微妙な構図をズームで調節できないためフットワークを活かした撮影者の機動性が作品づくりのポイントとなる。

ワンポイントアドバイス

「明るいレンズ」とは？

　レンズに書かれているF値は、絞りをいっぱいに開いた状態の値。その数値が小さいほど「明るいレンズ」と呼ぶ（F1.2やF1.4、F2など）。絞りは人の目でいう瞳孔の役割と同じである。瞳孔を大きく開くほど暗い場所でも光を短時間でキャッチできるし、強く眩しい光は瞳孔を小さく閉じて光量を調節する。これはカメラの絞りと同じ役割なのだ。よって、暗い中でのホタル撮影では、微弱な光をつかまえるためにも「明るいレンズ」が理想的になってくるというワケ。

アイテム①
水準器

暗い中で構図を決める際によく起こすミスは、画面が斜めになってしまうことである。ファインダー内が暗いため、なかなか水平にセットすることができないのだ。最近の一眼カメラには、水準器が内蔵されているものが増えた。また、以前からあるストロボのホットシューに付けるタイプでもいい。ホタル撮影にとっては必須のアイテムといえる。

アイテム②
液晶モニター

デジタルカメラの液晶モニターは、撮影後の画像確認や設定画面として重要な役割を担う。しかし、夜間の撮影ではモニターの明るさが周辺を照らす迷惑光にもなる。撮影後の確認は素早く行い、撮影時はOFFにする習慣を身につけたい。さらに無駄な光が周囲に飛ばないようにモニター輝度を暗くし黒い布や厚紙でカバーする配慮も必要だ。

アイテム③
比較明合成モードのカメラ

ホタル撮影でも多くの人が使う比較明合成は、パソコンでの作業が必要だったが、オリンパスのミラーレス一眼や高級コンパクトカメラに、カメラ内で「比較明合成」を行うモードが搭載されている。明るい部分のみが記録されていくので、風景の中に筆で描くようにホタルの光跡が写し出される。簡単に光跡を撮りたいならこれだ。

アイテム④
ケーブルレリーズ

ホタル撮影は、長秒シャッターとなるので、レリーズを使って、静かにシャッターを切りたい。なかでも、インターバルタイマーレリーズは撮影枚数から長秒時間などを自在に設定できる機能があり、使いこなせるとかなり便利だ。ただし、それらの機能を使うならば暗い中でも操作できるように事前に慣れておく必要がある。

アイテム⑤
三脚

カメラとレンズが用意できれば長秒シャッターを活用するための三脚が必要だ。三脚はある程度しっかりして機動性の活かせる中型三脚と自由雲台の組み合わせが最適である。小型三脚だと一眼レフを装着した場合、カメラブレを起こしやすくなるし、大きすぎると現場での移動が大変になる。三脚も暗闇の中で操作できるように練習しておきたい。

アイテム⑥
雲台

雲台は自由雲台がおすすめだが、締め付けが不十分だとブレの原因となる。心配な人は、3ウェイ雲台を使い、丁寧に締め付ければいい。三脚同様、こちらも暗い中で確実に操作できるようにしておこう。また、雲台に水準器が内蔵されているものもあるが、暗いと見えにくいので、カメラのホットシューに付けるタイプを選んだほうが確実だ。

ホタルをどう撮るのか？

環境を活かした撮り方を意識する

　ホタル撮影といえば、ホタルの光をとらえることを目的にした撮影が多いが、ホタルの撮影に慣れれば「ホタル飛ぶ風景」とした視点で考えるとさらに表現の幅が広がってくる。ホタルと風景の組み合わせは、種類に関係なくホタルの住む環境を画面の背景として構成することがポイントとなる。そのためには撮影地の選定から撮影ポイントまで吟味することで風景として完成度の高い作品づくりに結びつく。

街灯りも作品に取り込む

　まずはホタルと組み合わせる風景をどんな景観や光景にするかイメージしてみよう。ホタルの見られる場所は里山が多い、そこで普通に見られるのが小川や田畑である。少し広角に視野を広げれば里山ということになる。また、ホタルは市街地の近くに生息する環境もあり、住宅や街灯りが写り込むところもある。そんな身近な光景が画面の背景に広がっていれば作品としての見応えも大きく違ってくるだろう。

　実際の撮影では景色の中からポイントを見つけることが大切となる。ただし、

遠くの街灯りは空に反射し思わぬ色となって現れる。そんな変化も表現のうちである。

初めて出かける場所は状況も把握できない暗い環境が多いので昼間のロケハンは欠かせない。人工光のない山道沿いや森の中では真っ暗に近い場所も少なくない。暗い環境ほどファインダーで確認することは難しくなるが月明かりを活用するのも方法だ。いずれの条件も背景が写ることが重要なので、構図選びもよく考えて狙いたい。

ホタルの構図選び

ついつい横位置で撮ってしまう

　ホタルの撮影で意外に疎かになりやすいのが縦位置、横位置といった構図選びである。昼間の撮影とは違い現場の状況がわかりづらく薄暗い環境のため、ホタルの光は見えているが景色の状況や目標となるポイントが判別しにくいからだと言える。

　またカメラは基本的に横位置で使いやすく設計されていたり、心理的にホタルは横に飛んでいくものと思い込んでいる先入観もあって、ついつい構図のことを深く考えずに横位置で構える人が多い。その結果、ホタルは上手く画面に収まっても背景が中途半端な絵柄になっていることが多くなる。せっかくのホタル撮影なので現場の様子もわかるような背景を選ぶことも大切なポイントであるが、その光景に合わせて横位置だけでなく縦位置でも撮影しておきたい。

どう撮りたいかで構図は決まる

　ホタルは横移動ばかりでなく、上昇したり、下降したり縦移動する飛び方をする個体もいる。そんな上下するホタルの光跡を収めるには、出逢ったホタルがどんな飛び方をしているのかじっくり観察することも必要であり、飛翔する動きに適した構図をイメージしたい。

　さらに撮影に慣れてきたら、背景にマッチする構図を選択することが表現力アップの近道となる。林のように木々多いところで縦位置構図を選べば、絵柄から「高さ」を感じさせる状況描写となる。開けた田畑のような平地では横位置が「広がり」を感じさせる構図となる。また、星空を入れた構図を選べば「開放感」が伝わる。橋の上から川を見渡せる場所で縦構図を選べば「奥行き」を感じさせる表現となるなど、ホタルの飛び交う場所を見極め、前景・中景・遠景と前後する景観を重視すれば風景表現として完成度の高い構図が得られる。

> **ワンポイントアドバイス**
> **現場で微調整しながら追い込む**
> 　構図選びで気をつけたいのは、暗い場所では前後する景色の境が不明瞭になりひとつのシルエットになってしまうことである。テスト撮影で構図の修正や微調整を重ねていき完成度を高めよう。撮り逃がしたら来年まで撮影するチャンスが遠のいてしまうため構図選びには焦らず時間をかけ、余裕を持った行動をしよう。

川の流れを活かす=奥行きを表現　　　　　　星空を入れる=開放感を表現

横位置=広がりや奥行きを表現

ピント合わせの注意点

ポイントとなる場所に合わせる

　ベテランも初心者もはじめてのホタル撮影で最も悩むのがピント合わせだろう。しかし、ホタル撮影ではここをクリアしなければ作品づくりはできないと言えるほど重要なポイントである。

　ホタルの撮影では、ピントをホタルに合わせようとしても止まっているホタルは点光源で目立たないし、前後左右に無軌道で飛んでいるホタルには合わせられない。そのためクローズアップで狙わない限り、ポイントとなる草木を選び、それにピントを合わせたほうが見た目の構図が安定する。つまりピント位置は目的によって選び、必ずしもホタルに合わせる必要はないということである。どうしても飛翔にピントを合わせるならばピントを合わせた距離面を通過するタイミングを待つしかない。いわゆる置きピン撮影と同じ要領である。

AF補助光には要注意

　ホタル撮影のピント合わせには撮影者が守らなくてはならないカメラ操作の注意点がある。撮影の現場は暗いので、どんなに優れたカメラでもオートフォーカス（AF）が働かない。さらに設定によってはフォーカスモードがAFに設定さ

近くにいた撮影者のAF補助光が当たった例。この行為は、現場で口論を招くなどトラブルの原因にもなる。

れているとシャッターすら切れない。

　そのためAFモードでは、カメラが赤い光などを補助的に発光させピントを合わせるが、限界があり遠くの被写体では効果がない。それよりも問題は、夜行性のホタルにとってこの補助光は有害な光となるのでマニュアルフォーカス（MF）に設定してピントを合わせていく。

　また、補助光は撮影中の人の画面に写り込むと、そのカットをダメにしてしまう迷惑光でもある。なかにはポイントとなる個所に強烈なライトを照らし、交代でピント合わせをするグループや撮影者を見かけるが、これはホタルに悪影響を及ぼすだけでなく周囲に対しても迷惑行為なので絶対にやめていただきたい。

ピント合わせはMFにする

ホタルの撮影では、まずAFを解除してMFにする。通常、一眼レフの撮影でMFに切り替えるとピント合わせはファインダーで被写体を確認し、ピントリングを手動で動かして操作する。またはライブビューモードに切り替えてモニター画面を見ながら同様に手動でピント合わせを行う。しかし、ホタル撮影ではどちらの方法も被写体が確認できないほどの暗さなので合わせるのが難しいし、ライブビューの光は他人に迷惑をかけてしまうことになる。

明るいうちに
ピントを合わせておく

そこでピント合わせの最も確実な方法は、周囲が見える時間帯に撮影予定の現場で事前に合わせることである。これならAFでもピント合わせが可能だ。そしてピントを合わせた後にはAFからMFへの切り替えを行い、AFで合わせたピント位置が不用意に動かないようピントリングをテープで固定する。その際はMFに切り替えておかないと本番撮影で再びAFが作動し、せっかく合わせたピント位置がズレてしまうことになる。

確実性を高めていこう

レンズには距離目盛りがある（目盛りがないレンズもある）が、これを確認して目測で合わせる方法もある。ただし、ピントを合わせたい場所までの距離を目測するので、日頃から距離感をつかんでいたり、経験が必要となる。

そこで確実性を高めるのが以下の方法だ。一見、アバウトなピント合わせのようだが、慣れれば手早くできる。いきなり現場で実践するのは難しいので、自宅で練習しておこう。

覚えよう!
追い込みピント合わせ法

【手順❶】
距離が近ければレンズの距離目盛りを3〜5メートル付近に合わせる。10メートル以上離れた箇所なら「∞」の少し手前でよい。

【手順❷】
手順①の位置に合わせたら、とりあえず一枚テスト撮影してみる。

【手順❸】
テスト撮影した画像を背面モニターで確認し、拡大してピント位置を確認してみる。

【手順❹】
ピント位置がズレているようであれば、前後に微調整してピントが合うまで繰り返し、追い込んでいく。

ホワイトバランス(WB)

白を白として写す機能

　ホワイトバランスとは太陽光や室内光といったそれぞれの環境下で白を白として写す補正機能である。人は肉眼で白色を見ると室内外問わず白色に見える。これは人間の目が、「オートホワイトバランス機能」を持っているからだ。

　ホタルの撮影は夜間になるので、ホワイトバランスが合っているかの判断がしにくい。結論から言えば、ホタル撮影には意図がない限りオートホワイトバランスで問題ない。

　撮影する場所は市街地や里山が多く、街灯や民家の明かり、薄暮であれば空からの残光や月明かりなどが入り交じり暗い環境を浮かび上がらせている。だからこそ現場に目が慣れると辺りが見えはじめ、周囲の状況も確認できる。オートホワイトバランスは人間の目には見えない微弱な光にも反応するが、うまく補正できない光もあるので、街灯や街明かりによる色かぶりの影響は避けられない。

　注意したいのは「太陽光」である。太陽光は光源である太陽の色温度を基準とした設定で、日中の澄んだ光から太陽傾く頃の黄色味がかった光まで再現できるため太陽の光を活かした表現に適している。しかし、「太陽光」に設定して、夜間に撮影するとオレンジ色のナトリュウム灯や緑がかる水銀灯の光害を受けて強い色かぶりを起こしやすい。

　こうした色かぶりの補正はRAW現像時やJPEGの場合はレタッチでも行える。その際に便利なのが、ホワイトバランスのスポイトツールだ。これは画像の補正したい箇所にカーソルを持っていきクリックをすればいいだけ。ただし補正の必要がない箇所も色変換されてしまうため注意も必要だが、レタッチ中、何度もやり直せるので画面全体の色バランスを見ながら整えよう。

表現のためのWB調整

　ホワイトバランス調整では、カメラ設定とRAW現像時のどちらでも色温度の数値を任意に調整して色味をコントロールするマニュアル設定ができる。カメラで調節できる色温度は2500Kから10000Kと幅があり、一般撮影用には5200Kから5500Kが基準となる。この特性を活用すれば任意の色調を得ることができ、ホタル表現の幅も広がる。

　ただ、景色の色変換には効果的だが、ホタルの光にも影響が及んでしまう。そのためホタルの光は見た目の印象とは異なっていき色温度を低く設定すれば青白くなり、高くすれば黄色からオレンジ色に変化していく。

日陰

2000K　　　　　　　　　　　　　　　　　　　　　　10000K

太陽光

2500K　　　　オート　　　　8000K

蛍光灯

電球

　　縦軸はホワイトバランスのモードで設定、横軸は色温度の数値で設定している。一般的なホタルの印象からは遠ざかるかもしれないが、個性的な表現を目的にトライするならば効果的な手法となる。特に人気のブルー調表現【写真下】は夜の冷めた印象も高まるので試す価値はある。

絞りとISO感度の選択

ホタルの光は
絞りとISO感度で決まる

　飛んでいるホタルの光が写真に写る様子は、星の光跡や流れ星、そして夜空に舞う花火とよく似ている。さらに夜間に飛ぶ飛行機が点滅しながら移動していく様子やオーロラとも近いものがある。こうした移動する光が写真に写るには、シャッターを開いている間に光がどれだけカメラの中に入ってくるかが重要となる。その届いてくる光を制御するのが「絞り」と「ISO感度」である。通常はこれにシャッター速度も加わるのだが、ホタルの光をとらえることだけに限るとシャッター速度よりも絞りとISO感度の組み合わせで写るかどうか決まってくる。

　花火に例えると、【F11～F16／ISO100】。星ならば、【F2.8／ISO1600】と

いうのがひとつの目安であるが、ホタル撮影にも同様な値がある。ホタルのように輝度が弱い場合は、絞りを絞り込んでしまうと（Fの数字を大きく）光が写らない。そのため絞りを開け、高感度で撮影することが基本となる。ホタルの光跡が写る絞り値は、ホタルの種類にもよるが【ISO感度を1600】とした場合、ゲンジボタルの場合、【F2.8～F4】、ヘイケボタルは【F2～F2.8】、ヒメボタルは【F1.4～F2】となる。ゲンジボタルとヒメボタルでは、だいぶ値が違ってくる。そのため一般的な標準ズームで開放F値がF4のレンズではヒメボタルは写らないことになってしまう。

　そこでこの露出不足を補うのが「ISO感度」である。F4レンズを使用する場合はISO感度を3200～4800にセットすればF2.8レンズと同等の光をとらえることができる。ただし、感度を上げればノイズが出てきて、画面がざらつき始める。そのためヒメボタルを撮影する場合は、「明るいレンズ」をオススメするのである。

ワンポイントアドバイス
ISO感度ってなに？
　フィルム時代に使われていた規格で、数値の低いフィルムほど感度が低く、暗い光は写りにくい。そのためホタルの撮影では高感度のフィルムを必要とした。デジタルカメラは、一枚ごとにISO感度を変更でき、フィルム時代よりも高画質な写真が得られる。

覚えよう!
絞り値の目安(ISO1600の場合)
ゲンジボタル ➡ F2.8～F4
ヘイケボタル ➡ F2～F2.8
ヒメボタル 　➡ F1.4～F2

ヒメボタルは、最も弱い光なのでF1.4やF2の「明るいレンズ」を用いるほうが有利だ。また、開放で撮ることでヒメボタルの光を丸く表現できる上、レンズの近くを飛ぶホタルがいれば、ボケが大きくなり、幻想的なイメージを強調するメリットもある。

シャッター速度の選択

作品の印象を大きく変える

　ホタル撮影では絞り優先オートやマニュアル露出での撮影が有効である。オートでは多くのカメラがシャッター速度を30秒まで小刻みに選択できるが、絞りとISO感度との兼ね合い、現場の明るさにより選択できるシャッター速度は決まってくる。しかし、点光源や光跡を狙うホタル撮影では、シャッターを開いている時間＝シャッター速度が、光の数の差に現れるため作品の印象を大きく変える。よってどのくらいのシャッター速度を選ぶかが重要になってくる。

種類によって　シャッター速度は異なる

　ホタルは種類によって発光時間が異なる。しかし、その時間を考えればおおむねのシャッター速度は予測できる。
　発光時間の短いヒメボタルはおよそ0.8秒で点滅を繰り返す。そのため数秒のシャッター速度でも複数の光をキャッチできる。シャッター速度が10秒だったとしても10回強の点光源が写る計算だ。
　ゲンジボタルとヘイケボタルは、発光時間に個体差や地域差があるが、2〜4秒間隔で飛翔しながら点滅するため10秒だと2〜5回ということになる。特に光跡に写るこの2種は、飛ぶ速度も速く、移動距離も長い。カメラからホタルまでの距離が近ければ1回の発光で画面を通過してしまうことも起こる。逆に距離が離れていれば間隔を開けて点滅する光跡の全容をとらえることができる。それでも10秒では平均3回ということになる。
　ただし、すべての光跡が画面内に入るという保証はなく、シャッターを開いている途中に画面に入ってくる光跡も混在する。そうした点を考慮すると、景色の中を複数の光跡が右往左往する光景をとらえるには、10秒では中途半端に感じるだろう。たくさんの光跡を入れたい場合は、20秒から30秒のシャッター速度が必要となる。

「比較明合成」を活用する

　現在、20秒や30秒といったシャッター速度で1枚ずつ撮る方法のほかに、「比較明合成」という手法でホタルをとらえるのが人気だ。同じ構図のまま連続シャッターで撮影し、撮影後のレタッチ段階で「比較明合成」すると、背景の明るさは一定で点光源や光跡のみが加算されるというもの。シャッター速度が5秒でも6回連続撮影すればシャッターを開いていた時間が30秒になる。これにより理想的な光跡シーンを描くことができる。

ヒメボタル／シャッター速度＝30秒

ゲンジボタル／シャッター速度＝30秒

比較明合成によるホタル表現

デジタル時代の新しい表現方法

　ホタルに限らず、星空や花火撮影などで多用されるようになった「比較明合成」。これはベースとなる基本画像と合成する画像とを比較し、基本画像よりも明るい箇所を加えていくという合成方法である。つまり、同じ露出で撮ったものは、背景の明るさが一緒なので描写は変わらないが、ホタルの軌跡は基本画像とは違うところを飛んでいるため、光跡の部分のみが基本画像にプラスされていくイメージだ。ワンカットという限られた時間でカバーしきれないホタルの光を合算できるのがメリットだ。

ホタルが少なくても乱舞が実現!?

　ホタル撮影では乱舞する場面に遭遇すればいいが、そうでない日も多い。すると撮影を諦める人もいるが、そこで活躍するのが、「比較明合成」だ。仮にホタルの数が少なくても、飛んでさえいれば、長い間シャッターを開けることでその間に写る数や光跡の量も増えていく。
　例えば、30秒を10枚連続撮影した場合は5分間撮り続けたことになり、バルブ撮影で5分間露光した場合とシャッターが開いている時間は同じ。つまりホタルの光跡の量も同じになる。バルブシャッターを使用した長時間露出に限界のあるデジタルカメラでは、連続撮影した画像を合成してひとつの写真にする「比較明合成」のほうが高画質で、今までに見たことのないホタルの世界を表現することができる。

カメラ内か？ パソコンか？

　比較明合成の方法には、カメラにその機能が搭載された機種が発売されている。これなら構図を決めて適正露出を導ければ、あとは撮影をストップさせるまで、面白いようにホタルの光跡がカメラ内に記録されて一枚の作品として完成する。
　一方、撮影後にレタッチソフトを活用し合成する方法は同じ露出で何枚もシャッターを切り、後からパソコンで合成していく。メリットは連続して撮影したカットから任意のものを選んで合成できるので、「車のライトが入って失敗した」と思ったカットを外すことができ、完成度を高められる。
　Photoshopなど画像処理ソフトでも合成処理ができるが、専用フリーソフトを使うと簡単かつ素早く合成処理ができるのでおすすめだ。比較明合成によって、思いも寄らない写真が楽しめる。

比較明合成の手順
※ Photoshop を使った例

【手順❶】
合成するファイルをすべて開く、ここでは2枚。枚数が多くなるとパソコンの動きが鈍くなる。ベース画像に重ねるファイルを選び、ツールバーの「選択範囲」➡「すべてを選択」する。

> **ワンポイントアドバイス**
> **専用のフリーソフトが便利**
>
> ここでは Photoshop を使った手順を説明しているが、専用ソフトを使用すると簡単に自動処理できる。代表的なものは「シリウスコンポ」（Win専用）や「キクチマジック」（Win専用）。「Ster Stax」（Mac & Win）である。まずはこうしたフリーソフトを活用して比較明合成を経験するとホタル表現の楽しみは倍増する。

【手順❷】
選択された画像をベースとなる画像にコピー＆ペースト。

【手順❸】
ベース画像のレイヤーパレットに合成するカットのレイヤーができる。そこで、レイヤーパレットの「描写モードを設定」を開き「比較（明）」を選択。ホタルの光だけがベース画像に重なり合成した画面になる。

【手順❹】
レイヤーパレットの右上角をクリックし「画像の統合」を選択。レイヤー画像をベース画像に統合して一枚画像が完成する。

適正露出を導く手順

ISO感度は1600を基本とする

　ホタルの撮影に限らないが、写真はISO感度・絞り・シャッター速度の組み合わせであるが、ホタルを撮る場合は、種類と撮影環境を加味していく必要がある。
　薄暮から夜にかけての暗い環境下であるため普段の撮影と大きく異なるのがISO感度の値である。まずは、時間帯と現場の暗さからISO1600を基本とする。ただし、明るいようであればISO800、暗いようであればISO3200など、柔軟に対応していきたい。

絞りは開放付近を選ぶ

　ISO感度が決まれば、次は絞り値。弱い光に対して少しでも多くの光を集めるため使用レンズの開放値付近を選択。ヒメボタルをきれいな丸で表現したい場合は、迷わずレンズの開放値を選ぶ。また、開放絞り値がF4などやや暗いレンズなら、ISO感度を高めに設定し、ハンディを補うといい。

シャッター速度は状況による

　最後にシャッター速度の選択である。シャッター速度とは、シャッターが開いている時間だが、絞りとISO感度の選択が適正であれば、その間にカメラの前を横切るホタルはすべて写る。シャッター速度が速ければその数が少なく、遅ければホタルの数や光跡もたくさん写る。

覚えよう！

適正露出を導く手順

【手順❶】ISO感度を決める
基本はISO1600だが、撮影時間帯や周囲の状況を見て、明るければISO800、暗ければISO3200も考える。

【手順❷】絞り値を決める
使用するレンズの開放付近（F1.4やF2.8など数字が小さいほう）を選択。
※ヒメボタルを丸く表現したいなら開放を選ぶ

【手順❸】シャッター速度を決める
上記のISO感度と絞り値で、背景が狙い通りに描写されるシャッター速度を選ぶ。一枚撮影の場合は、選択したシャッター速度でどのくらいホタルが描写されるかも考える必要がある。

【手順❹】マニュアル露出にセットする
シャッター速度が決まれば、オートで撮影してもいいが、マニュアル露出に切り替え、ISO感度、絞り、シャッター速度を設定すれば、その後は一定の明るさで撮ることができる。ただし、構図や光の状況が変わったら再度設定しなければならない。

さらにシャッター速度は背景の明暗の写り方をコントロールする役目もある。そのシャッター速度は数秒から数十秒まで、撮影する時間帯や月明かりの有無、街灯など環境光によっても左右される。まずは絞り優先オートでカメラが導くシャッター速度を確認しながらテスト撮影をし目安を見つける。

> **ワンポイントアドバイス**
> **マニュアル露出時の露出補正⁉**
>
> 　絞り優先オートの場合、マイナス側に露出補正すると、ISO感度と絞りは固定なので、シャッター速度を速くすることで暗くなる。マニュアル露出の際、明るいと感じたらシャッター速度を速くし、暗いと感じたらシャッター速度を遅くすることで同様の結果が得られる。もちろん、明るければISO感度を低く、暗ければ高くしてもいい。

露出オーバー

露出アンダー

適正露出

ホタルの最適露出

露出ミスが起こりやすい

　ホタルの撮影で難しいのはホタルの種類によって異なる適正露出の導き方である。そこで写る光の色や形を種類別に比べてみると……
【ゲンジボタル】濃い黄色から明るい黄色で光跡の両端は細く中央は太い。
【ヘイケボタル】やや緑を帯びた黄色で光跡はゲンジボタルと良く似ているが太さの強弱が少なく直接的で細い。
【ヒメボタル】点光源が黄色からオレンジ色を帯びる。カメラからの距離やピント位置の違いで写り方が極端に変化する。

段階露出や
テスト撮影をしよう

　こうしたホタルの光は、適正露出を外れると色の濃淡に違いが現れる。露出オーバーでは色が薄く、白飛び傾向となり、露出不足だと黒っぽく濁った黄色系になる。段階露出やテスト撮影から適正露出を探ろう。露出の過不足は、RAW形式で撮影しておけば現像時に補うことも可能だ。しかしどんな色に写れば適正な露出なのかは知っておきたい。

ゲンジボタル

ヘイケボタル

露出オーバーでホタルの光が白飛び気味になった例。これではホタルらしさが失われてしまう。

ヒメボタル

風景としての適正露出

風景とのバランスを考える

　ホタル表現のひとつとして、「ホタルの舞う風景」を狙うのもいい。その際は、ホタルの光を撮る時の露出とは少し違ってくる。「ホタルの舞う風景」には、夜の雰囲気が漂う背景がほしいのだが、それにはホタルと風景をバランスよく見せるための露出を考えなければいけない。実は、ここに「ホタルの舞う風景」の難しさがある。

絞り優先オートで撮る場合

　もっとも手軽な露出決定は、絞り優先オートで撮影する方法である。この方法の利点は風景に対しての露出選びが求めやすいことにある。ポイントになるのは露出補正だ。夜の撮影は暗い状況なのでカメラの露出計は明るく再現しようと実際よりもオーバー傾向の露出になりやすい。そのためカメラの示す露出に対してマイナス補正をする必要が出てくる。

　この露出補正の加減は、状況やカメラの機種によっても異なるが、マイナス１〜２EVの大幅な補正をすることで見た目に近い再現が得やすくなる。この補正はシャッター速度で調整するため絞りと感度で適正が求められるホタルの光の露出には大きく影響しない。ただし、夕暮

ここでは風景としての適正露出を導き、渓流の表情を引き出した。ただし、これ以上明るくなるとホタルの飛ぶ雰囲気がなくなってしまうのでギリギリのところだ。

れの明るい薄暮シーンでは、シャッター速度が短くなりすぎてしまい飛んでいるホタルの光跡が中途半端な量になってしまうこともある。その際は、絞り値を少し絞ったりISO感度を落としたりして工夫するとよい。

よくある失敗と対策

全然写らない!?

　夜間撮影は思いもよらないトラブルやアクシデントが発生する。「シャッターは切れるが何も写らない」というケースは様々な原因が考えられるが、心理的に慌ててしまい冷静さが失われていて、落ち着いて機材のチェックをすれば気づくことが多い。なかでも多いのがキャップをしたまま撮影してしまううっかりミス。ウソのような話だがこれは用意周到に準備をする人ほど招きやすい。

　次に多いのが、絞りを絞り込み過ぎているケース。F値の明るいレンズを使用している人に多いミスで、「F2.8」と「F22」を読み間違えてセットしてしまう。またISO感度1000と100を見間違うことも。シャッター速度を30秒にセットしたつもりが1/30秒になっていたり……。これは初心者に限らずベテランでも起こしやすいセットミスである。液晶の文字は小さく見づらいので注意したい。

メモリーカードが入っていない!?

　ほかにもミラーアップにセットしたことを忘れて撮影するなんてことも。ミラーアップはシャッターを切ると開始するが30秒で元に戻る。その戻る音をシャッターが閉じたと勘違いするのである。ホタル撮影ではミラーアップは必要ないので常に使用する人は解除しておくようにしたい。これは普段から風景撮影を得意とする人に多い。

　また、メモリーカードが入っていない、メモリーカードがいっぱい、ということもある。メモリーカードについてはシャッターごとにカメラのモニターやファインダー内に警告表示されるが、それに気がつかないことで起こる。これはレリーズを押しっぱなしにした連続シャッターでシャッターを切った後、その場を離れたりする撮影者に多い。

比較明合成のため5秒にセットしたつもりが1/5秒になっていて思い通りに写らなかった例。

ピンぼけを防げ！

　ホタルの光跡はピントが合っていれば点光源や光跡がシャープなラインを見せる。ところがピンぼけは、ヒメボタルの場合は大きな円形ボケとなり、ゲンジやヘイケボタルの光跡は明らかにぼけたラインとなる。このうちヒメボタルの場合は、表現効果として活用できるボケなので幸いすることもあるが、光跡のボケは目立ってしまい逆効果となる。

　失敗としての「ピンぼけ」とはどこにもピントがあっていないケースや意図したところがなぜか大きくぼけている場合である。こうしたケースはピント位置が1メートル以下の近距離にセットされていたり、数メートル先の近場を撮影しているのに「∞」にセットされているときに多く見られる。ピントを合わせたあとにテープで固定していないとポジション移動の際など、不用意にレンズに触れてしまい、ピントリングが回ってしまうことも多い。

ピントは固定しておこう

　また複数のレンズを使い分けているとレンズ交換の脱着でせっかくテープで固定したピントリングをまわしてしまう場合もある。さらに開けた場所で広角レンズを使って撮影していると、遠方の民家の明かりや空の雲にピントを合わせてしまうケースもある。いずれにしても暗闇で行う操作なのでそれに気がつかないことも多い。特にMFにしているとピンぼけの善し悪しに関係なくシャッターが切れてしまうので注意が必要だ。こうしたミスを防ぐためにも、ピントを合わせたあとはテープでしっかりと固定するように心がけたい。

光跡のボケは意外と目立つ。

ピント位置が手前に動いてピンボケになった。

ブレを防ぐための基本

　ホタルに限らずブレた写真というのは、シャッターが開いている間にカメラが動いてしまう「カメラブレ」と被写体が動く「被写体ブレ」のことを指す。ホタル撮影は、長秒シャッターを必要とするので手持ち撮影では100パーセントカメラブレが起こる。そのため三脚を使って撮るのが基本である。

　しかし、三脚を使っても撮影者の操作ミスや油断によってブレは発生する。もっとも多いのは脚のネジが緩んでガタガタしているケースだが、いずれにしても三脚各部の締め付けが不十分だとカメラブレの発生率は高くなる。特に三脚を伸ばした状態で脚の締め付けが緩んでいると脚が収縮して撮影中に三脚が倒れるという最悪のアクシデントも危惧されるので十分注意したい。

三脚に触れないように注意

　自由雲台を使用し、タテ位置構図で撮影する場合、カメラを雲台の左側に配置することで発生する縦ブレにも注意したい。これはレンズの重さでカメラの締め付けが緩む現象である。構図を決める時、カメラの位置を雲台の右側に配置すると、カメラを雲台に締め付ける方向に負荷がかかることでカメラの緩みを防ぐことができる。こうした三脚や雲台のネジの締め付けの甘さはどれもカメラブレに繋がるので撮影時は注意だ。

　またホタル撮影ならではのブレとして、暗闇の中で動いていて、知らずに三脚につまずきカメラにショックを加えてしまうケースがある。これは、単なるブレだけでなく、せっかく決めた構図も動いてしまう。ホタルの光跡はさほど目立たないが、背景の絵柄がズレてしまう。そのうえ、足場が軟らかく、不安定な撮影地では三脚に触れなくても撮影者が移動しただけで三脚が動くこともあるので慎重に行動したい。

雲台の右側にカメラが位置するようにすると緩みを防ぐことができる。

左側にカメラを配置すると締め付けが緩む可能性が高くなるので要注意。

バルブ撮影のデメリット

　フィルム時代から行われた方法にバルブ（BULB）シャッターを使用した長時間露出という撮影方法がある。シャッターを押したままにすれば何時間でもシャッターが開いているので、花火や星の撮影で活用される。ホタルの撮影でも30秒以上の長秒シャッターを必要とする場合に活用することもある。

　このバルブシャッターのメリットはたくさんあるが、デメリットについては意外に知られていない。そのひとつに、フィルムには相反則不軌（シャッターを開く時間が長くなるほど実効感度が低くなりカラーバランスも崩れてくる）があり、露出時間を伸ばしても露出オーバーになりにくかった。ところがデジタルカメラにはこの相反則不軌がないため感度が維持され、長時間露出の際には限界を超えてしまい、完全に露出オーバーとなって画面が真っ白になってしまう。フィルムであれば10分を超えるような長時間露出もあったが、デジタルでは難しいケースもあり、比較明合成（78〜79ページ）で対応するなどの方法を使うといい。

デジタルは長時間露出が苦手!?

　絞りを開放にして高感度で撮影するホタルでは数分が限界となる。また、デジタル撮影はシャッターが開いている時間が長いほどノイズも増加し、数分のバルブ撮影ではホタルの光かノイズなのか区別がつかないほど荒れてくる。さらに気温の高くなる夏場の撮影では撮像素子が熱を持ち発生する「熱ノイズ」「アンプノイズ」と呼ばれるピンク色をしたシミのような広がりも画面に現れる。ある程度のノイズならばレタッチで軽減できるが、この熱ノイズは補正が難しい。気温の高い夜にバルブ撮影を行うと、意外な落とし穴があるので要注意である。

6分のバルブ撮影をした写真を部分拡大したもの。フィルムとは違いノイズが目立ってくる。ノイズリダクション機能や比較明合成など、様々な方法で高品質の写真に仕上げる工夫をしたい。

どのくらい乱舞させるのか？

乱舞しすぎに注意!?

　ホタル撮影では乱舞する光景は魅力的なシーンである。デジタル時代になって可能となった比較明合成は、あまり飛んでいない時期に訪れた時や、乱舞しなかった日でも、構図を変えずに何枚も撮影すれば、乱舞のシーンを再現することができる。

　しかし、ここで問題となるのが乱舞と印象づける光の数である。作品のインパクトを強めるために、多くの画像を比較明合成し、見た目の印象を遙かに超える作品をつくることもできる。実際に、数が多ければ多いほど、見た人の驚きも大きい。だが、闇雲に合成すればいいと考えるのは安易である。

　ホタル撮影には生態を観察する目的で現実的に撮る科学写真と風景的な視点で観賞を目的とした作品づくりの撮り方があるが、比較明合成で乱舞を再現することは、実際の現場の状況と違ってしまうことになる。たった一匹しか飛んでいなくても、それを何シーンも合成すればあたかも乱舞しているかのような写真になる。合成作品の難しさはここにある。

比較明合成のポイント

　比較明合成で作る理想的な乱舞シーンは、景観に見合った光の舞いが、バランスよく展開していることだろう。しかし、ホタルの飛び具合をコントロールすることはできない。そのため連続撮影した中から順番通りに合成していくのではなく気に入った写真のみを選択し、比較明合成する方法をすすめる。これにより完成度を高められる。

　選択の際には、背景に対してどの位置にどの程度の光が集まり、どんな飛び方をしていて、背景にマッチするのかを考える。特に乱舞をイメージさせる光の集合体だけでは不十分な場合、画面から去っていくような直線的な光跡をアクセントにすると変化がついていい。

　選んだ画像は、まず比較明合成のテストをし、そこから過不足を見ていくようにする。ヒメボタルのような点光源の場合は、光の移動量が少ないので地面に光が敷き詰められるような絵柄を求めるには何十枚もの合成が必要になることもある。ゲンジやヘイケボタルのような光の線を描くホタルには、数枚から10枚未満の合成を心がけると煩雑な印象が避けられる。

　数の少ない合成は専用ソフトによる一括合成を避けて、手間は少しかかるがレイヤー合成での比較明合成をすれば光の重なりによる目立つ箇所の修正や加減も調整しやすい。

風情はあるが
これでは
少ない印象。

これくらいで
ちょうどいい。

インパクトはあるが、
現場での印象を
超えてしまっている。

少ない

光の数

多い

星と絡ませる

超広角レンズでとらえる

　よく晴れた日に郊外に出かけると夜空にはこんなにも星が煌めいているのかとしばらく見入ってしまうことがある。ホタル撮影の楽しみにそんな星空とホタルの光をコラボしてみる方法もある。

　一般的なホタル撮影では、目の前の光景や風景との組み合わせが多く、どうしてもレンズはホタルの集まる方向に向く。星空と組み合わせるためにはレンズを星空に向けることになる。そうなればアングルはやや上に向けなければならないのだが、そこで、レンズの選択が重要になってくる。

　標準的な画角では両者をひとつの画面に収めるのは難しい。さらにピントの問題もあり、ホタルに合わせれば星はピンぼけになり、星にピントを合わせればホタルはさらに大きくボケてしまう。そこでピントの合う範囲（被写界深度）が広い魚眼レンズや広角レンズを使用することで両者のコラボを導くのである。

　この方法の大きな問題点は、一般的にはあまり使用しないレンズを用意しなくてはならないことだ。風景撮影を好む人なら持っているだろうが、16ミリや24ミリといった領域をカバーできるレンズも増えているので所持しているレンズの焦点距離や画角を確認してみよう。

森の中から16ミリの超広角レンズで見上げるとホタルと星が一緒に煌めいていた。

ホタルの露出は星と一緒

　星空とのコラボでは、星座を意識した構図も選択できるが、まずはホタルの光を優先するので背景として星が写っていればよい、ぐらいの意識でいい。露出もホタルと星は適正値がほぼ同じなのでホタルが写る露出であれば星も写る。ただし、シャッター速度によっては星数が少なかったり、星が棒状になる。

　ピント位置は広角であればひとまず「∞」のやや手前付近にセットし、テスト撮影から最適な位置を追い込む方法がおすすめ。星に合わせると近くを飛んでいるホタルはピンぼけ状態になる。

北斗七星とホタルを絡める。ソフトフィルターを使って、光の印象を強めている。

比較明合成で合計5分相当の露光時間になると星の線が繋がり、軌跡となって現れる。

ポジションとアングル

　この撮影で難しいのは撮影ポジションとアングルだ。ホタルが通常の目線よりも高いところを飛んでいれば、上にカメラを向けて星空が入る構図を選べばいい。しかし、低いところを飛んでいる場合にはポジションを下げて見上げるアングルを選ばないといけない。その際、構図が確認しづらくなるので慣れも必要。

　どちらの撮影もヨコ位置よりも、タテ位置構図のほうが、高さに対して対応できるので星空までの構図を作りやすい。だが、超広角や魚眼レンズで狙う奇抜なレンズワークでは弱点も存在する。広角であればあるほど視野が広くなり、星空も広範囲に写り込むが、離れたところを飛んでいるホタルの光跡は小さくなり目立たない。ホタルが飛ぶ印象を強めたいのであれば、中景付近に多く飛んでいるポイントを選んでカメラをセットして撮ること。

　また長時間、連写した画像をすべて比較明合成すればホタルの光跡がたくさん写り、星は線となって繋がり光跡撮影となる。北にカメラを向ければ、星空撮影で人気の星がぐるぐる回る軌跡とホタルの舞いを撮ることもできる。ただし、両者の光跡同士が重なり合い煩雑な絵柄となりやすいことも覚えておきたい。

風景とホタルを別に撮る

ホタルと風景の露出を合わせる

　風景的な視点でホタルを撮影する場合は、周りの景色を活かし、メリハリのある構図を見つけることが基本である。その中を群れるホタルの光がとらえられれば情緒的な風景となる。

　この撮り方には通常のホタル撮影と同様にストレートの一枚撮りで決める撮り方と比較明合成を活用する方法がある。どちらの方法も風景に適した露出とホタルの露出をマッチさせることがポイントだ。しかし、刻一刻と変化する宵闇では風景とホタルがマッチするケースばかりとは限らない。特に風景の露出が明るすぎればホタルが目立たず、反対に暗すぎれば風景の味わいが薄れてしまう。両者を最適に導くことが理想だが、これが予想以上に難しい。

風景の先撮りがおすすめ

　そこで紹介するのが、それぞれを適正露出で撮影し、その画像を合成する方法である。別々の場所で撮影した絵柄ではなく、カメラは動かさず、構図は同じ状態での比較明合成が前提となる。風景とホタルを別撮りするには、どのタイミングでどちらを撮影するのか、であるが、結論的にはどちらを先に撮影してもいい。ただし、風景を撮影する時はホタルが飛んでいないタイミングが理想的だ。

　夜を待たず、あまり早い時間帯に風景を撮ってしまうとホタルが飛ぶ光景とは見えず、不自然になるのでおすすめできない。そこで風景を選んだら日没後の薄暮のタイミングを待ち、ホタルの飛ぶ直前に撮影する方法が自然な雰囲気を表現しやすい。

　風景の先撮りではISO感度や絞りの設

明るすぎるとホタルが舞う光景とは不釣り合いになってしまう。

定をホタルとは異なる値で撮影できる利点がある。低いISO感度で撮影可能なので画像の荒れを低減できる。しかし、絞りを絞り込み、パンフォーカスで撮ると、ホタルは絞りを開けて撮るためピントの浅い描写となり不自然な合成表現になってしまう。絞りは、2段程度の絞り込みにとどめておくといい。

　風景の後撮りは先撮り同様にホタルの飛ばないタイミングでの撮影だが、夜も更けてくると景色は暗くなるため露出時間が長くなるリスクがある。

①風景を先に撮影したもの

②カメラはそのまま固定しておき、ホタルを撮影したもの

①と②を比較明合成すると、風景の雰囲気が見えつつ、ホタルが舞う光景を表現できる。

ノイズ低減処理

ノイズリダクションのデメリット

　カメラにはノイズと言われる画像の荒れを目立たないようにする「ノイズリダクション機能」が内蔵されている。主に高感度と長秒シャッターに対するノイズリダクションである。メニュー画面からそれぞれのノイズに合わせた処理が選択でき、必要に応じてON・OFFも可能であるが、比較するとざらつきが補正されていることがわかる。また、デジタル一眼カメラの一部の機種には長秒時の連続撮影中でもノイズ処理できる便利なAUTOの選択ができる。

　ただし、一般的な機種の長秒シャッターは、シャッターを開いた時間に比例してノイズが増える特性があるため、シャッターが閉じた直後から同じシャッター速度分だけ、カメラ内部でノイズリダクション処理が行われる。つまりは30秒露光したら、ノイズ処理にも30秒かかり、1枚撮影するのに60秒を要することになる。よって、連続シャッターができないというデメリットもある。

　また、ノイズとホタルの点光源がよく似ているためノイズリダクションの強さによってはホタルの光までも軽減されてしまうことがある。ホタルの光が見た目以上に少ない場合は、この機能が働いていることがあるので、撮影前には設定やその強弱を確認しておこう。

　私の設定は【高感度ノイズ(標準)ON】にして【長秒時露光のノイズ低減】は連続撮影を優先したいので基本は【OFF】に設定している。露出時間が短い場合にはAUTOに設定し連続撮影することもある。

ノイズ処理の方法

　RAW現像やレタッチ段階でのノイズの除去にはレタッチソフトによってさまざまな方法がある。しかし、ツールの存在そのものがわかりづらい場所にあったりして、うまく活用できていない人もいる。そのためか初心者にはハードルが高そうに感じるが扱い方は手軽、だれでも簡単にできる。RAW画像もJPEG画像も同様に処理できるのでまずは試してもらいたい。

　一般的なノイズには「輝度ノイズ」と「色ノイズ」がある。どちらもパソコンの画面に画像全体を表示させた状態ではノイズの実態がわかりにくい。そこで、ノイズのチェックをする際には、画面の表示を100パーセントから200パーセント程度に拡大表示し確認していく。その上で、どんなタイプのノイズが発生しているのかを判別し、処理していくのが基本だ。

※Photoshop Camera Rawの場合

【色ノイズ処理】

色ノイズ処理は、色そのものを薄めていく方法である。処理ボリュームを上げればノイズの色はなくなるが同時に必要な色情報まで失われることがあるため控えめな処理を心がけることが美しく仕上げる秘訣である。

> **ワンポイントアドバイス**
> カメラに付属しているRAW現像ソフトでも同様の処理ができる。自分が使いやすいソフトで行えばいい。

200パーセント表示などにするとノイズの様子がわかりやすい。

【輝度ノイズ処理】

ノイズそのものをぼかすことで背景に馴染ませる方法。そのため過度の処理をすればノイズ以外の画像にもぼかし効果が働き、全体画像はソフトフィルターで撮影したようなぼんやりした印象になってしまうので要注意。調整のさじ加減は拡大したプレビュー画像を全体画面に戻してソフト感のない程度がいい。完全処理の7割程度に止めることがコツである。

【色ノイズ処理】
カラーノイズ処理を施した様子。色が消えるまでボリュームを右へスライドし75で消えたので、ここでOK。

【輝度ノイズ処理】
処理を施し、ざらつきを低減させた。ボリュームを右へスライド。50までと少し控えめに処理して画像の軟調化を抑えている。

画像処理の基本テクニック
①明るさ

明るさ調整4つの方法

　「明るさ」は撮影した画像の露出を補正する処理で、「もう少し明るく」とか「暗くしたい」という明暗調整を行うレタッチである。だれでも簡単にできる処理から高度な処理までさまざまな方法がある。レタッチソフトによって操作ボタンやツールの名称に違いもあるため初めてレタッチをする人は困惑しやすい。

　一般的に明るさ調整のできるツールには、以下の4つがある。
【明るさ】テレビやパソコンの画面の明るさを調整するのと同じ意味合いで画面全体の明るさを調整する。もっとも手軽な処理方法でボリュームの上げ下げのように調整できわかりやすいが、細かい調整はできない。
【露出】これはRAWデータに対応した現像時の調整方法で、撮影時の露出倍数と同じように加減ができる。
【レベル補正】画像データはシャドウからハイライトまでの情報を棒グラフで表したヒストグラムというグラフの一種で表すことができ、明るさの違いを横軸、縦軸に量を表している。このグラフ化したデータ情報を元にして明るさを調整する手段が「レベル補正」である。
【トーンカーブ】シャドウからハイライトまで斜めの線グラフで正比例を示したツールである。トーンカーブの調整は明るさだけでなく、RGBそれぞれの色調整やコントラストなど部分的な補正までコントロールできる奥の深い上級者向けのツールである。

おすすめはレベル補正

　4つある明るさ補正のうち、おすすめはヒストグラムを見ながら調整できる「レベル補正」である。

　ホタルの写真は基本的に暗い画像が多いのでヒストグラムを見れば画像情報の山が中央から左寄りになっているだろう。ホタル写真に多い、極端に暗いと感じる露出不足の写真は、ヒストグラムの画像情報の山が左の壁にぴたっと寄り添うように接近し、山の形も急勾配だ。ちなみにホタル写真でも露出をかけ過ぎた露出オーバーの写真では、ヒストグラムの山は右寄りに位置する。こうした失敗と感じる写真や、「まぁまぁいいけど、もう少し明るく」といったリカバリーに「レベル補正」は威力を発揮する。

　レベル補正の基本的な使い方がわかれば、撮影時にアンダーになった画像や明るい雰囲気を醸し出すようなイメージ表現も後処理で補うことができる。ただし、

やや暗くなってしまった写真を明るくしたい。調整は、ヒストグラムの真ん中にある▲マークを左に移動させるだけでいい。

画面で補正具合を見ながら少しずつ動かしていく。明るくなった写真を暗くしたい場合は、▲マークを右寄りに移動させていけばいい。

やり過ぎは画像の荒れを強調するため無理な処理は控えたい。

レベル補正を覚えよう

　レベル補正での明るさ調整は、ヒストグラムの下に配置された▲マークだ。左端・中央・右端の3カ所に配置されている。この中の中央にある▲を左右にスライドすれば明るさが変動する。左に動かせば明るくなり、右に動かせば暗くなる。微調整する場合は数値入力もでき、細かな調整ができる。

　レベル補正は、ヒストグラムの山をゴムひもに例えれば、短いひもを引っぱり、伸ばすということだ。元データを幅広にすればデータの隙間も空いてしまう。そこで保存の際、周辺の画像を元に穴埋め（補間）する仕組みである。そのため強引な処理は補間も多くなり、結果的に画像も荒れるので画像を確認しつつほどほどの調整を心がけたい。

画像処理の基本テクニック
②彩度

色の濃度を調整する

　彩度とは色の濃い薄いといった濃度を調整するレタッチである。ソフトによってはRAW現像の中で「色の濃さ」と名称表記しているものもある。彩度はボリュームを上げれば色が濃くなり派手な色彩になる。上げすぎると色の階調が破綻し色飽和を招き、反対にボリュームを下げれば色が浅くなり、最終的に色のないモノトーンになる。

　ホタルの写真は、一般的な色の豊富な写真とは対照的でどちらかと言えば、背景が暗くモノトーンに近い。それは露出設定がホタルメインで撮影されており、背景に対して色を再現できるだけの露出を与えていないからである。薄暮や明るい環境光がある場合は、補助光効果で背景も薄らと色の確認ができる。こうした色浅い背景に飛ぶホタルはしっかりと色濃度を持った光として描写される。ホタルの種類によっては黄色系から黄緑系、黄色に近いオレンジ系といった色の違いがある。

彩度の上げすぎには注意

　ホタルの光に対して彩度を上げれば強調され色濃くなり、光が目立ち印象的に

オリジナル画像

なる。しかし、彩度を高めすぎると色の破綻が起きてフラットな階調のない光の色となることもある。また、この彩度の調整は同時に背景にも影響し今まで目立たなかった草むらの色や街灯に照らされた部分の色が強調され、予想外の色変化を招く弊害も起きてくるので調整には注意が必要だ。

　彩度調整で強調されやすい色に草むらや木々の緑色がある。彩度を上げすぎると暗い背景の中で緑色だけが目立ってしまう。パソコンの画面では気づきにくいが、プリントにすると目立つ場合があるので、気になるようであれば、彩度を控えめに調整し直すといい。

全体の彩度を「34」に。空の赤い部分などがほどよく鮮やかになり、メリハリ感のある色彩になった。

全体の彩度を「50」に。空の部分などにトーンジャンプが見られるようになる。光跡も鮮やかすぎる。

全体の彩度を「80」に。ここまで来るとトーンジャンプも激しく、完全に画像が破綻している。

完成

先ほどの「34」より少し鮮やかにするため全体の彩度を「42」とした。ただ、ホタルの色が鮮やかすぎて不自然。そこで、「マスター」を押して、「グリーン系」を選択。これで画面内のグリーン系の色だけを調整できる。ここでは、あえて彩度を落として、「−53」にして、全体のバランスを整えた。

※Photoshopでの作業例

画像処理の基本テクニック
③色かぶりを補正する

色の偏りを補正する

　ホタル撮影時の「色かぶり」とは街灯など撮影地の近くで灯る環境光から発せられる光が画面にかぶってくる現象である。最近増えているナトリュウムなどのオレンジ色や水銀灯の緑色といった光である。人間の目はこうした光を自動補正しているため写真に撮らないと気づかない。この色かぶりを補正するのが、カメラに備わったホワイトバランス機能だが、オートでは調整しきれない色域や色味があるため色かぶりとして画面に残ってしまうのである。

　特に残りやすい色かぶりは、波長の長いナトリュウム灯のオレンジ色かぶり、また街灯りが混在する光からの影響が大きい。そこでカメラ機能では補正できなかった色かぶりをレタッチで補正するというのがここでのテクニックである。

簡単に補正する方法

　色かぶり補正では、気になる色味が解消されると、元々影響を受けていない箇所の色が変わってしまうことがある。そこで完全な補正を目指すよりも両者のバランスを見極めながら気にならない程度の軽減を目指すことがコツである。

　単色の色かぶりであれば意外に簡単な方法で補正できる。そのひとつが「スポイトツール」を使ってホワイトバランスをとる方法である。

　この方法はレタッチソフトに備わったツールのひとつで「クイックホワイトバランス」ともいわれる。画面の中で補正したい箇所にスポイトツールを持っていきクリックするといたって簡単な方法だ。何度も繰り返すことができ、その都度、瞬時に色合いが変化する。何度も繰り返す間にどれがいいか迷うこともあるが、そんな時にはキャンセルすれば元画像に戻すことができる。テストアンドトライを繰り返し、色変化の傾向に慣れることが習得への近道だ。

補正のポイント

　ここでのポイントは、画像の中に写っている白色の部分や黒っぽい箇所をクリックすればある程度の色の偏りはなくなる。私はガードレールや無彩色に近い木々の幹にスポイトを持っていくことが多い。さらに高度な色かぶり補正ではPhotoshopの「色相・彩度」やCamera Rawを使い、特定色の彩度や輝度をコントロールして色かぶりの元となる色域を低く調整する方法もある。

左側にある緑をクリック

コンクリート部分をクリック

流れの白濁部分をクリック

蛍の光をクリック

日陰部分をクリック

※ここではPhotoshopのCamera Rawを使って補正しているが、多くのソフトに同じようなホワイトバランスを調整する機能がある。

Column 3

撮影時の喜怒哀楽が
ホタル撮影の醍醐味

　ホタル撮影の楽しみは、自分の選んだ構図に飛び交う光が織りなし、見た目とは違った摩訶不思議な光景として独特な絵柄に浮かび上がることにある。シャッターを開いている時間が長くなるほど「このカットにはどんな光が写るのだろう」という少しの不安と期待が交錯し、カメラの前を行き交うホタルを祈るような気持ちで眺めることになる。シャッターが開いている限られた数十秒の間には、自分の中でイメージする絵が写し込まれるのだが、撮影した写真を見ると期待以上の写りであったり、ときには「あれっ」「どうして？」と落胆することもある。そんな撮影時の喜怒哀楽や戸惑いがホタル撮影への興味につながり、好奇心が芽生えるのである。
　ホタル撮影は、昼間に撮るような速いシャッター速度でその場の瞬間をとらえる写真とは大きく異なる。薄暗い静的な背景に加えて、不規則な動きをする動的な光をとらえるという「静と動」の混在表現である。そこに撮影の難しさがある。今やデジタルカメラの進歩によって、薄暗い環境であっても撮ることそのものは簡単になったが、自由気ままに飛び交うホタルをすべて自分の思ったように写すことは難しい。そんなホタル撮影だからこそ普段とは違った醍醐味が隠されているのだろう。

第4章

ホタルに逢う

全国ホタルガイド

①住所 ②期間 ③アクセス ④連絡先

※状況によってカメラ撮影が不可のこともあります。また、駐車場はピーク時には大混雑することがあります。そのほか、入場料や事前予約が必要なところ、観賞時間に制限があるところがありますので事前にご確認ください。

～北海道・東北～

【北海道】十勝が丘公園（音更町）
①十勝川温泉北14 ②7月上旬～下旬 ③JR帯広駅から車20分 ④☎0155-32-6633

【北海道】ほたるの里（沼田町）
①幌新377 ②7月上旬～8月上旬 ③深川留萌道・沼田ICから車15分 ④☎0164-35-1188

【青森】細越栄山地区（青森市）
①細越字栄山595 ②6月下旬～7月下旬 ③JR新青森駅から車20分 ④☎017-739-6414

【青森】吹越地区（横浜町）
①吹越567-1 ②7月上旬～中旬 ③JR吹越駅から徒歩7分 ④☎0175-78-3213

【岩手】小岩井農場（雫石町）
①丸谷地36-1 ②6月下旬～7月下旬 ③東北道・盛岡ICから車15分 ④☎019-692-4321

【岩手】折爪岳山頂（二戸市）
①福岡折詰地内 ②7月上旬～中旬 ③八戸道・九戸ICから車15分 ④☎0195-23-7210

【秋田】ぽよよんの森オートキャンプ場（東成瀬村）
①椿川字間木 ②6月中旬～8月上旬 ③湯沢横手道路・十文字ICから車50分 ④☎0182-47-5555

【秋田】水沢温泉郷（仙北市）
①田沢湖生保内 ②7月上旬～8月中旬 ③東北道・盛岡ICから車60分 ④☎0187-43-2111

【宮城】鱒淵地区（登米市）
①東和町米川字軽米地内 ②6月下旬～7月中旬 ③JR石越駅から車40分 ④☎0220-34-2734

【宮城】南原ホタルの里（大崎市）
①鳴子温泉南原 ②6月下旬～7月下旬 ③JR中山平温泉駅から車7分 ④☎0229-87-2361

【宮城】金成翁沢地区（栗原市）
①金成翁沢 ②6月中旬～7月初旬 ③東北道・若柳金成ICから車10分 ④☎0228-22-1151

【福島】産ヶ沢川ホタル自然公園（桑折町）
①半田・万正寺地区 ②6月中旬～7月上旬 ③JR桑折駅から徒歩10分 ④☎024-582-2126

【福島】ホタルの森公園（会津若松市）
①北会津町下荒井字宮ノ東 ②6月中旬～7月上旬 ③磐越道・会津若松ICから車15分 ④☎0242-58-2381

【福島】レンゲ沼（北塩原村）
①レンゲ沼 ②7月中旬～8月上旬 ③磐越道・猪苗代磐梯高原ICから車30分 ④☎0241-32-2349

～関東～

【茨城】七ツ洞公園（水戸市）
①下国井町2457 ②6月中旬 ③常磐道・水戸北ICから車5分 ④☎029-232-9214

【茨城】南指原ほたるの里（笠間市）
①南指原 ②6月上旬～7月下旬 ③JR笠間駅

から車20分 ④☎0296-77-1101

【茨城】袋田温泉(大子町)
①袋田 ②6月中旬～7月中旬 ③常磐道・那珂ICから車50分 ④☎0295-72-3011

【栃木】名草ほたるの里(足利市)
①名草下町大字大坂 ②6月上旬～下旬 ③北関東道・足利ICから車5分 ④☎0284-41-9977

【栃木】須花坂公園(佐野市)
①下彦間町1575-1 ②6月中旬～下旬 ③北関東道・佐野田沼ICから車20分 ④☎0283-27-3012

【群馬】八幡ホタルの郷(榛東村)
①新井674 ②6月中旬～7月下旬 ③関越道・渋川伊香保ICから車20分 ④☎0279-54-5145

【群馬】ホタルの里(前橋市)
①田口町861-1 ②6月上旬～下旬 ③関越道・渋川伊香保ICから車15分 ④☎027-234-3873

【群馬】月夜野ホタルの里(みなかみ町)
①上毛高原駅西側 ②6月中旬～7月上旬 ③JR上毛高原駅から徒歩5分 ④☎0278-25-5017

【千葉】源氏ぼたるの里(いすみ市)
①山田四・五区地先 ②5月下旬～6月上旬 ③JR大原駅から車20分 ④☎0470-62-1243

【千葉】清和ほたるの里(君津市)
①豊英 ②6月上旬～7月下旬 ③館山道・君津ICから車35分 ④☎0439-38-2117

【千葉】白浜フラワーパーク(南房総市)
①白浜町根本 ②5月中旬～6月中旬 ③富津館山道路・富浦ICから車40分 ④☎0470-38-3555

【埼玉】下吉田関地区(秩父市)
①下吉田 ②6月中旬～7月上旬 ③関越道・花園ICから車50分 ④☎0494-77-1111

【埼玉】秩父ミューズパーク(小鹿野町)
①長留2518 ②6月下旬～7月上旬 ③関越道・花園ICから車50分 ④☎0494-25-1315

【東京】玉川上水青梅橋付近(福生市)
①熊川 ②6月中旬～下旬 ③JR牛浜駅から徒歩10分 ④☎042-551-1699

【東京】夕やけ小やけふれあいの里(八王子市)
①上恩方町2030 ②6月上旬～下旬 ③中央道・八王子ICから車30分 ④☎042-652-3072

【神奈川】七沢温泉(厚木市)
①七沢1826 ②5月中旬～6月中旬 ③東名高速・厚木ICから車15分 ④☎046-240-1220

【神奈川】万葉公園(湯河原町)
①万葉公園内花木園 ②6月上旬～中旬 ③真鶴道路終点から車15分 ④☎0465-62-3761

【神奈川】松葉沢ほたるの里(愛川町)
①半原 ②6月上旬～中旬 ③圏央道・相模原愛川ICから車20分 ④☎046-285-2111

～甲信越～

【山梨】万力公園(山梨市)
①万力公園 ②6月中旬～下旬 ③JR山梨市駅から徒歩5分 ④☎0553-20-1400

【山梨】ほたるの里秋葉公園(北杜市)
①長坂町大八田 ②6月中旬～7月上旬 ③中央道・長坂ICから車5分 ④☎0551-42-1453

【山梨】一色地区(身延町)
①一色 ②5月下旬～6月下旬 ③JR下部温泉駅から車15分 ④☎0556-62-1116

【山梨】小田川ほたるの里(韮崎市)
①中田町小田川 ②6月上旬～下旬 ③JR韮崎駅から車10分 ④☎0551-22-1111

【長野】狐塚ほたるの里（上田市）
①塩川 ②6月中旬～下旬 ③しなの鉄道大屋駅から徒歩15分 ④☎0268-23-5408

【長野】なべくら高原の蛍（飯山市）
①なべくら高原柄山 ②7月上旬～下旬 ③上信越道・豊田飯山ICから車40分 ④☎0269-69-2888

【長野】花見ほたるの里（池田町）
①花見2566-1 ②6月下旬～7月中旬 ③JR信濃松川駅から車10分 ④☎0261-62-9197

【長野】松尾峡のホタル（辰野町）
①辰野ほたる童謡公園 ②6月中旬～下旬 ③JR辰野駅から徒歩15分 ④☎0266-41-1111

【長野】志賀高原石の湯（山ノ内町）
①志賀高原石の湯 ②7月～8月上旬 ③上信越道・信州中野ICから車50分＋徒歩20分 ④☎0269-34-2404

【新潟】岩室温泉冬妻ほたる（新潟市）
①西蒲区岩室温泉 ②6月中旬～7月上旬 ③JR岩室駅から車8分 ④☎0256-82-1066

【新潟】大月ほたるの里（南魚沼市）
①六日町大月地区 ②6月中旬～7月上旬 ③関越道・六日町ICから車15分 ④☎025-773-6665

【新潟】塚野山牛ノ首地区（長岡市）
①塚野山 ②6月下旬～7月上旬 ③JR塚山駅から徒歩20分 ④☎0258-92-5903

～北陸～

【富山】滝地区（高岡市）
①滝 ②6月中旬～7月上旬 ③JR高岡駅から車20分 ④☎0766-36-1135

【富山】仁歩ほたるの里農村公園（富山市）
①八尾町三ツ松957 ②6月中旬～7月中旬 ③JR越中八尾駅から車25分 ④☎076-458-9111

【石川】丸山公園（白山市）
①瀬戸丸山公園 ②6月中旬～7月中旬 ③北陸道・小松ICから車50分 ④☎076-256-7840

【石川】日用川のホタル（小松市）
①牧口町・日用町 ②6月中旬～7月上旬 ③JR粟津駅から車15分 ④☎0761-24-8067

【福井】ホタルの里公園（おおい町）
①名田庄槇谷 ②6月中旬～7月上旬 ③舞鶴若狭道・小浜ICから車40分 ④☎0770-77-1734

【福井】南川流域（おおい町）
①名田庄小倉地区 ②6月中旬～下旬 ③JR小浜駅から車25分 ④☎0770-67-3000

【福井】一乗谷（福井市）
①城戸ノ内町・安波賀町 ②6月中旬～下旬 ③JR一乗谷駅から徒歩10分 ④☎0776-20-5346

～東海～

【静岡】上垂木ホタルの里（掛川市）
①上垂木坂下バス停付近 ②5月下旬～6月中旬 ③JR掛川駅から車15分 ④☎0537-21-1149

【静岡】南沢ホタルのせせらぎ公園（富士宮市）
①内房山口地内 ②5月下旬～7月中旬頃 ③JR芝川駅から車15分 ④☎0544-65-0601

【静岡】大川温泉竹ケ沢公園（東伊豆町）
①大川 ②6月上旬～中旬 ③伊豆急行伊豆大川駅から徒歩20分 ④☎0557-95-0700

【愛知】小幡緑地ホタルの里（名古屋市）
①守山区牛牧字中山 ②6月上旬 ③名鉄小幡駅から徒歩15分 ④☎052-793-2491

【愛知】名古屋城(名古屋市)
①中区本丸 ②5月中旬～6月上旬 ③地下鉄名城線・市役所駅から徒歩5分 ④☎052-231-1700

【愛知】相生山緑地(名古屋市)
①天白区相生山 ②5月下旬 ③地下鉄桜通り線・野並駅からバス ④☎052-803-6644

【愛知】鳥川ホタルの里(岡崎市)
①鳥川町 ②5月下旬～6月上旬 ③名鉄本宿駅から車20分 ④☎0564-82-3027

【愛知】平原ゲンジボタルの里(西尾市)
①平原町前山地内 ②6月中旬 ③名鉄西尾駅から車10分 ④☎0563-55-3515

【岐阜】金生山明星輪寺(大垣市)
①赤坂町4610 ②6月上旬～中旬 ③JR大垣駅から車20分 ④☎0584-71-0124

【岐阜】菅田川(下呂市)
①金山町菅田地内 ②6月中旬～下旬 ③東海環状道・富加関ICから車30分 ④☎0576-24-2222

【岐阜】飛鳥川(揖斐川町)
①谷汲神原 ②6月上旬～中旬 ③東海環状道・大垣西ICから車50分 ④☎0585-55-2231

【三重】鈴鹿ほたるの里(鈴鹿市)
①西庄内町 ②5月下旬～6月中旬 ③東名阪道・鈴鹿ICから車10分 ④☎059-380-5595

【三重】榊原温泉(津市)
①榊原 ②6月上旬～7月上旬 ③伊勢道・久居ICから車20分 ④☎059-252-0017

【三重】大台町内(大台町)
①栗谷・浦六・高奈・弥起井 ②6月上旬～7月下旬 ③紀勢道・大宮大台ICから車15分 ④☎0598-84-1050

～関西～

【滋賀】守山市民運動公園(守山市)
①ほたるの森資料館横のほたる河川 ②5月下旬～6月中旬 ③名神高速・栗東ICから車20分 ④☎077-583-9680

【滋賀】天野川一帯(米原市)
①長岡周辺 ②6月上旬頃～中旬 ③名神高速・関ヶ原ICから車30分 ④☎0749-58-2227

【京都】八瀬(京都市)
①左京区上高野東山 ②6月上旬～中旬 ③叡山電鉄・八瀬比叡山口から徒歩1分 ④☎075-752-7070

【京都】谷川ホタル公園(井出町)
①多賀天王山 ②5月下旬～6月下旬 ③JR山城多賀駅から徒歩10分 ④☎0774-82-6168

【京都】宝ヶ池 椿の道(京都市)
①左京区岩倉東五田町 ②6月上旬～中旬 ③地下鉄烏丸線・国際会館前から徒歩1分 ④☎075-752-7070

【大阪】摂津峡公園(高槻市)
①塚脇 ②6月上旬～下旬 ③JR高槻駅から車20分 ④☎072-687-9449

【大阪】山中渓(阪南市)
①山中渓 ②6月中旬 ③阪和道・阪南ICから車5分 ④☎072-471-5678

【大阪】明治の森箕面国定公園(箕面市)
①箕面公園 ②6月中旬～下旬 ③阪急箕面駅から徒歩5分 ④☎072-721-3014

【奈良】室生川のホタル(宇陀市)
①室生 ②6月上旬～7月上旬 ③名阪国道・小倉ICから車30分 ④☎0745-82-2457

【奈良】蛍公園(曽爾村)
①太良路 ②6月中旬～下旬 ③名阪国道・針ICから車50分 ④☎0745-94-2106

【奈良】洞川温泉(天川村)
①洞川 ②6月下旬～7月上旬 ③近鉄下市口駅から車50分 ④☎0747-64-0333

【和歌山】かつらぎ町ほたるの里(かつらぎ町)
①下天野 ②6月中旬～7月上旬 ③JR笠田駅から車20分 ④☎0736-22-0300

【和歌山】きしべの里(紀の川市)
①貴志川町井ノ口 ②6月上旬 ③和歌山電鐵・貴志駅から徒歩5分 ④☎0736-64-2525

【兵庫】中畑工場公園(西脇市)
①中畑町・畑谷川 ②5月下旬～6月中旬 ③JR西脇市駅から車15分 ④☎0795-22-3111

【兵庫】八千代町ホタルの宿路(多可町)
①八千代区俵田 ②6月上旬～中旬 ③中国道・滝野社ICから車20分 ④☎0795-37-0250

【兵庫】奥米地区ホタルの里(養父市)
①奥米地 ②6月上旬～下旬 ③JR和田山駅から車15分 ④☎079-665-0588

～中国～

【岡山】由加(倉敷市)
①児島由加 ②5月下旬～6月中旬 ③瀬戸中央道・水島ICから車30分 ④☎086-473-1115

【岡山】福地川(高梁市)
①落合町福地 ②6月上旬～中旬 ③JR備中高梁駅から車20分 ④☎0866-21-0461

【岡山】豊岡川(吉備中央町)
①豊岡 ②6月上旬～下旬 ③岡山道・有漢ICから車30分 ④☎0866-54-1301

【岡山】宇内ホタル公園(矢掛町)
①宇内 ②6月上旬 ③井原鉄道小田駅から車5分 ④☎0866-82-1010

【岡山】北房ほたる公園(真庭市)
①下砦部 ②6月上旬～下旬 ③中国道・北房ICから車15分 ④☎0866-52-2112

【鳥取】三朝川周辺(三朝町)
①三朝 ②6月上旬～中旬 ③中国道・院庄ICから車80分 ④☎0858-43-0431

【鳥取】樗谿公園(鳥取市)
①上町87 ②6月中旬～下旬 ③JR鳥取駅から車10分 ④☎0857-22-3318

【鳥取】金田川ほたるの里(南部町)
①金田 ②6月上旬～中旬 ③米子道・溝口ICから車20分 ④☎0859-30-4822

【鳥取】福万来(日南町)
①山上地区福万来 ②6月下旬～7月中旬 ③日南町役場から車20分 ④☎0859-82-0933

【島根】津和野川(津和野町)
①枕瀬 ②6月中旬 ③JR日原駅から徒歩1分 ④☎0856-72-0652

【島根】口羽地区(邑南町)
①下口羽 ②6月中旬～7月上旬 ③JR口羽駅から徒歩10分 ④☎0855-95-2565

【島根】赤川ホタル(雲南市)
①大東町・赤川流域 ②5月下旬～6月中旬 ③JR出雲大東駅から徒歩20分 ④☎0854-40-1054

【広島】ほたる見公園(庄原市)
①口和町大月2-1 ②6月中旬～7月中旬 ③松江道・口和ICから車3分 ④☎0824-87-2513

【広島】湯来温泉(広島市)
①佐伯区湯来町 ②6月中旬～7月中旬 ③JR五日市駅から車60分 ④☎082-247-6738

【広島】滝山峡(安芸太田町)
①滝山橋上流一帯 ②6月下旬〜7月上旬 ③加計市街から車5分 ④☎0826-28-1800

【山口】佐波川河川敷(防府市)
①本橋町ほたる広場 ②5月下旬〜6月中旬 ③山陽道・防府東ICから車5分 ④☎0835-25-4547

【山口】竜王山公園(山陽小野田市)
①小野田字番屋ヶ獄1261 ②5月中旬〜6月中旬 ③山陽道・小野田ICから車25分 ④☎0836-82-1162

【山口】豊田町(下関市)
①豊田町中村 ②5月下旬〜6月下旬 ③JR小月駅から車25分 ④☎083-766-0031

〜四国〜

【香川】ホタルと文化の里公園(高松市)
①塩江町安原上602 ②5月下旬〜6月中旬 ③徳島道・脇町ICから車25分 ④☎087-893-0148

【徳島】美郷ほたる館(吉野川市)
①美郷字宗田82-1 ②5月下旬〜6月中旬 ③JR阿波山川駅から車10分 ④☎0883-43-2888

【徳島】黒川谷(三好市)
①山城町頼広 ②6月中旬 ③JR阿波川口駅から車30分 ④☎0883-76-0877

【徳島】母川(海陽町)
①高園 ②6月上旬〜下旬 ③JR海部駅から徒歩15分 ④☎0884-76-3050

【愛媛】柳沢地区(大洲市)
①矢落川上流 ②6月上旬〜6月中旬 ③松山道・大洲ICから車30分 ④☎0893-24-2664

【愛媛】中山町(伊予市)
①中山町 ②5月下旬〜6月中旬 ③松山道・伊予ICから車25分 ④☎089-982-1111

【愛媛】柿原川(内子町)
①平岡 ②5月下旬〜6月中旬 ③JR内子駅から車10分 ④☎0893-44-3790

【高知】才谷・瓶岩地区(南国市)
①才谷・瓶岩 ②5月下旬〜6月上旬 ③JR後免駅から車20分 ④☎088-880-6557

【高知】高瀬沈下橋周辺(四万十市)
①高瀬 ②5月中旬〜6月上旬 ③土佐くろしお鉄道中村駅から車20分 ④☎0880-35-4171

【高知】下津井地区(四万十町)
①下津井橋下の河原 ②5月下旬〜6月下旬 ③JR土佐大正駅から車35分 ④☎0880-27-5008

〜九州・沖縄〜

【福岡】黒川周辺(北九州市)
①八幡西区上香月 ②5月下旬〜6月中旬 ③JR黒崎駅から車20分 ④☎093-582-2491

【福岡】棚田親水公園(東峰村)
①つづみの里 ②5月下旬〜6月中旬 ③JR大行司駅から徒歩10分 ④☎0946-74-2311

【福岡】小塩川周辺(うきは市)
①浮羽町小塩 ②5月下旬〜6月中旬 ③大分道・杷木ICから車30分 ④☎0943-75-4975

【大分】本匠のホタル(佐伯市)
①本匠堂ノ間鹿渕 ②5月中旬〜6月中旬 ③東九州道・佐伯ICから車40分 ④☎0972-56-5111

【大分】白山川(豊後大野市)
①三重町中津留 ②5月下旬〜6月下旬 ③JR三重町駅から車30分 ④☎0974-22-2616

【大分】宝泉寺温泉～町田川一帯(九重町)
①町田 ②5月下旬～7月上旬 ③大分道・九重ICから車25分 ④☎0973-76-3866

【佐賀】祇園川(小城市)
①小城町・松尾・岩倉 ②5月下旬～6月中旬 ③JR小城駅から車5分 ④☎0952-37-6129

【佐賀】武雄温泉(武雄市)
①武雄町大字永島 ②5月下旬～6月上旬 ③JR武雄温泉駅から車15分 ④☎0954-23-9237

【佐賀】中の原地区(有田町)
①中の原 ②5月下旬～6月中旬 ③JR有田駅から徒歩20分 ④☎0955-43-2121

【長崎】多以良川ホタルの里河川公園(西海市)
①大瀬戸町多以良郷 ②6月上旬～中旬 ③西海パールライン・小迎ICから車30分 ④☎0959-37-5833

【長崎】鮎もどし自然公園(対馬市)
①厳原町(瀬川沿い) ②6月上旬～中旬 ③対馬空港から車50分 ④☎0920-52-1566

【長崎】木場町(長崎市)
①木場町公民館付近 ②5月中旬～6月上旬 ③長崎バイパス・川平ICから車20分 ④☎095-829-1156

【熊本】渡瀬川・二鹿来川(菊池市)
①旭志小原 ②5月中旬～6月上旬 ③九州道・熊本ICから車30分 ④☎0968-25-7223

【熊本】一つ目水源(山鹿市)
①久原 ②5月中旬～下旬 ③九州道・菊水ICから車30分 ④☎0968-43-7211

【熊本】わいた温泉郷(小国町)
①西里岳の湯2816 ②6月上旬～8月 ③大分道・玖珠ICから車50分 ④☎0967-48-5277

【熊本】塩浸川(合志市)
①上庄227 ②5月下旬～6月上旬 ③九州道・熊本ICから車30分 ④☎096-248-1111

【宮崎】出の山公園(小林市)
①南西方 ②5月下旬～6月中旬 ③JR小林駅から車10分 ④☎0984-22-8684

【宮崎】北川(延岡市)
①北川町川内名 ②5月下旬～6月上旬 ③JR延岡駅から車20分 ④☎0982-46-5010

【宮崎】千野川のホタル(串間市)
①本城千野川周辺 ②4月下旬～5月初旬 ③JR串間駅から車7分 ④☎0987-72-0479

【鹿児島】平房ホタルの里(鹿屋市)
①輝北町平房 ②5月中旬～6月上旬 ③九州道・溝辺鹿児島空港ICから車70分 ④☎0994-86-1111

【鹿児島】軸谷橋下流(出水市)
①上鯖渕 ②5月中旬～下旬 ③JR出水駅から車10分 ④☎0996-63-2111

【鹿児島】ホタルの里「荒川」(いちき串木野市)
①荒川 ②5月中旬～下旬 ③南九州道・串木野ICから車15分 ④☎0996-32-3111

【沖縄】末吉公園(那覇市)
①首里末吉町1-3-1 ②5月～6月 ③ゆいレール儀保駅から徒歩10分 ④☎098-951-3229

【沖縄】五枝の松園地(久米島町)
①上江洲 ②4月下旬～11月上旬 ③久米島空港から車15分 ④☎098-985-7115

【沖縄】久米島ホタルの里 自然公園久米島ホタル館(久米島町)
①大田420 ②4月～11月 ③久米島空港から車15分 ④☎098-896-7100

第1章　撮影データ

カバー＿キヤノンEOS5D MarkⅡ・EF50mmF1.4・F1.4・15秒×30回（比較明合成）・ISO1600・AWB

01＿ CanonEOS60D・EF24mmF1.4Ⅱ・F1.4・30秒×90回（比較明合成）・ISO1600・AWB

02＿ CanonEOS5D MarkⅡ・EF35mmF1.4・F1.4・25秒×16回（比較明合成）・ISO1000・AWB

03＿ CanonEOS60D・EF35mmF1.4・F1.8・15秒×70回（比較明合成）・ISO2500・AWB

04＿ CanonEOS60D・EF35mmF1.4・F1.4・15秒×25回（比較明合成）・ISO2500・AWB

05＿ CanonEOS60D・EF70-200mmF2.8・F4・30秒×4回（比較明合成）・ISO1250・AWB

06＿ CanonEOS5D MarkⅢ・EF24-70mmF2.8・F2.8・15秒・ISO2500・AWB

07＿ CanonEOS5D MarkⅡ・EF24-70mmF2.8・F3.5・15秒×6回（比較明合成）・ISO1600・AWB

08＿ CanonEOS5D MarkⅢ・EF24-70mmF2.8・F3.5・10秒×21回（比較明合成）・ISO1000・AWB

09＿ CanonEOS5D MarkⅢ・EF24-70mmF2.8・F3.2・20秒・ISO1250・AWB

10＿ CanonEOS60D・EF16-35mmF2.8・F2.8・13秒×4回（比較明合成）・ISO1250・AWB

11＿ CanonEOS5D MarkⅡ・EF70-200mm F2.8・F4・30秒・ISO1600・AWB

12＿ CanonEOS5D MarkⅢ・EF24-70mmF2.8・F2.8・30秒×16回（比較明合成）・ISO1250・AWB

13＿ CanonEOS5D MarkⅡ・EF70-200mmF2.8・F5.6・15秒×27回（比較明合成）・ISO800・AWB

14＿ CanonEOS5D MarkⅡ・EF16-35mmF2.8・F2.8・20秒・ISO1600・AWB

15＿ CanonEOS5D MarkⅡ・EF24-70mmF2.8・F4・13秒×24回（比較明合成）・ISO1250・AWB

16＿ CanonEOS60D・EF16-35mmF2.8・F4AE（－1.3補正・8秒）×130回（比較明合成）・ISO800・AWB

17＿ CanonEOS5D MarkⅡ・EF16-35mmF2.8・F2.8オート（－0.7補正・25秒）・ISO1600・AWB

18＿ CanonEOS5D MarkⅡ・Tamron180mm F3.5・F5.0・5秒・ISO1600・AWB

19＿ CanonEOS5D MarkⅡ・EF70-200mmF2.8・F4・30秒×5回（比較明合成）・ISO1600・AWB

20＿ CanonEOS5D MarkⅢ・EF24-70mmF2.8・F2.8・25秒×4回（比較明合成）・ISO1600・AWB

21＿ CanonEOS5D MarkⅡ・EF24-70mmF2.8・F2.8・25秒×3回（比較明合成）・ISO2500・AWB

22＿ CanonEOS5D MarkⅡ・EF135mmF2・F2.0・25秒・ISO1600・AWB

23＿ CanonEOS60D・EF24-70mmF2.8・F2.8・30秒・ISO2000・AWB

田中達也 Tatsuya Tanaka

1956年、愛知県生まれ。医療ソーシャルワーカーを経て自然写真家として独立。身近な自然から風景・オーロラと幅広いジャンルを手がけ、繊細で力強い作風を特徴とする。オーロラと風景を組み合わせた一連の作品は海外からも高く評価されている。『オーロラの本』『オーロラ旅物語』『空のどうぶつえん』『月星夜空の撮影術』『星の絶景を撮る』ほか著書多数。日本写真家協会・日本自然科学写真協会。

参考文献・資料

『ホタルの不思議』大場信義（どうぶつ社）
『ホタル』中山れいこ（少年写真新聞社）
『ホタルの光は、なぞだらけ』大場裕一（くもん出版）
『光の芸術家 ホタル』日高敏隆・栗林 慧（株式会社アスク）
『ホタル 光のひみつ』栗林 慧（あかね書房）
『天竜川のホタル』勝野重美（天竜川上流工事事務所）

蛍の本

発 行 日	2015年5月20日 初版第一刷発行
著　　者	田中達也
発 行 人	石井聖也
編　　集	藤森邦晃
営　　業	片村昇一
発 行 所	株式会社日本写真企画
	〒104-0032 東京都中央区八丁堀3-25-10 JR八丁堀ビル6F
	TEL 03-3551-2643　FAX 03-3551-2370
デ ザイン	福田　浩（セント・ギャラリー）
印刷・製本	図書印刷株式会社

本書の収録内容の無断転載、複写、引用は著作権法上での例外を除き禁じられています。
落丁・乱丁の場合はお取り替えいたします。

ISBN978-4-86562-010-8　C0072　¥1800E
ⒸTatsuya Tanaka 2015, Printed in Japan